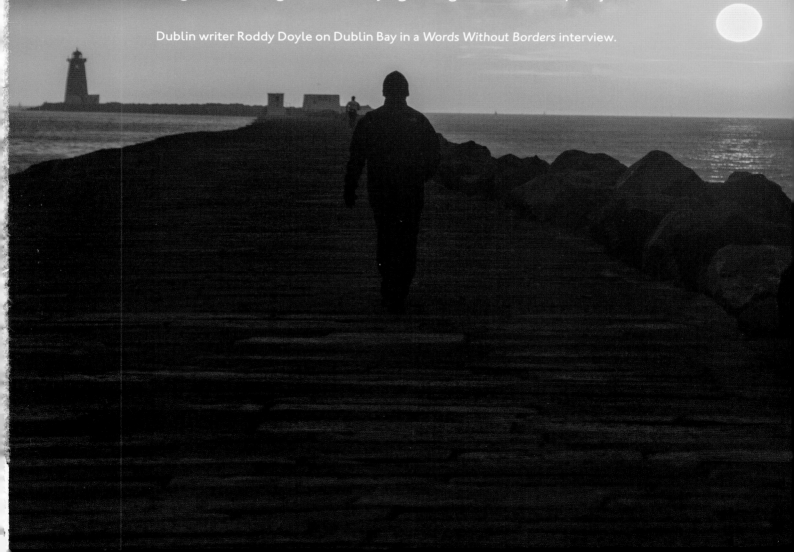

DUBLIN BAY

"

I live a five-minute walk from the sea. From the bottom of my street I can see the Spire, in the city centre, and the docks, ferries and container ships coming and going, the mountains to the south of the city, the Hill of Howth to the east, planes flying over the hill, arriving.

I find it exhilarating and, sometimes, inspiring – especially when the seagulls are filling the air and trying to sing 'Bohemian Rhapsody'.

Dublin writer Roddy Doyle on Dublin Bay in a *Words Without Borders* interview.

SEÁN KENNEDY EFIAP

Seán is a well-known Dublin photographer with a particular interest in street and landscape photography. He has been an active member of the Dublin Camera Club since 1983 and is a past president. His work has attained international recognition from the Fédération Internationale de l'Art Photographique (EFIAP), a worldwide organisation representing photographic art. In 1993 he was elected Artist FIAP (AFIAP), and in 1997 he was awarded Excellence FIAP (EFIAP). His work has competed and been exhibited both nationally and internationally.

Originally from Boyle, County Roscommon, Seán, with his wife Mary and daughter Niamh, moved to the picturesque village of Sandymount, in Dublin, in 1984. This put Dublin Bay on his doorstep and fostered his great appreciation for the beauty of Dublin Bay and the varied scenery it had to offer. Seán can often be found on the Great South Wall, especially on stormy days, taking his life into his own hands trying to capture that beauty in images.

NIAMH KENNEDY

Sean's daughter, Niamh, grew up with Sandymount Strand and its surrounds as her playground. The iconic Poolbeg Chimneys formed a backdrop to her childhood and will forever signify home to her. Niamh is a keen walker and occasional cyclist, and in the undertaking of writing text for this project has relished the opportunity to explore, by both modes, all that Dublin Bay has to offer.

Niamh works in financial services and lives in the shadow of her beloved Poolbeg Chimneys in Ringsend, Dublin.

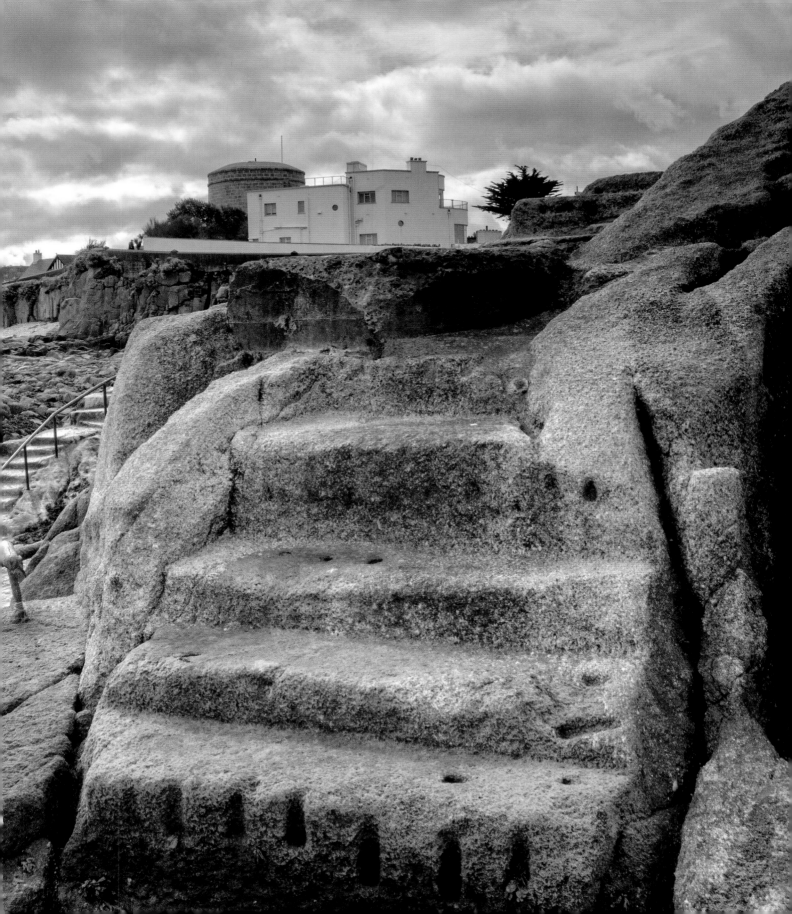

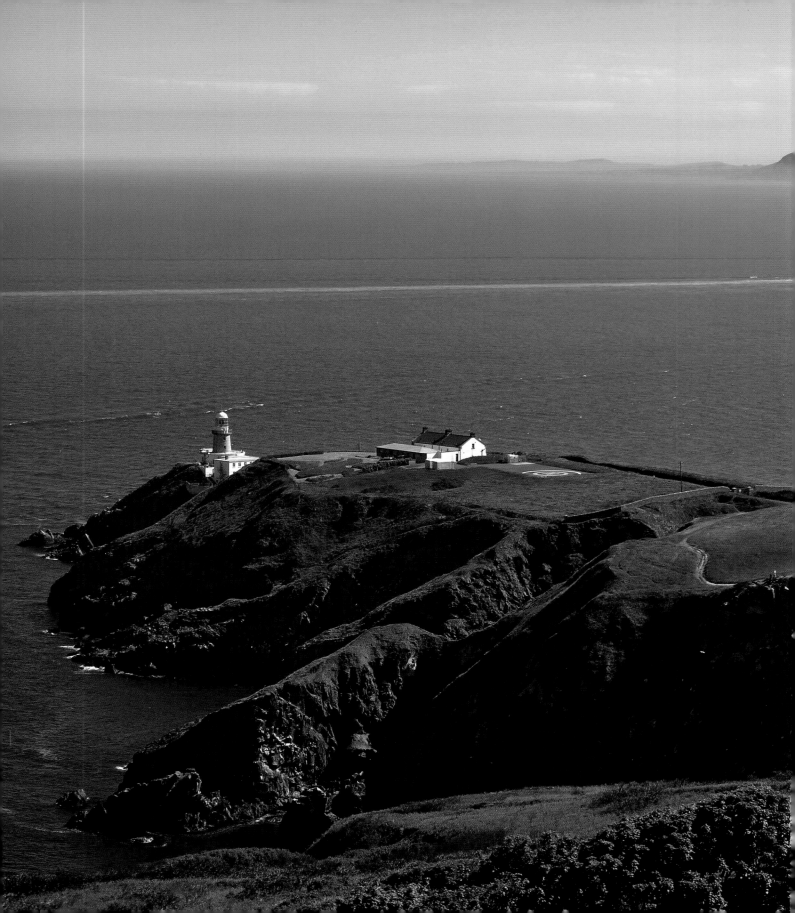

DUBLIN BAY
CITY BY THE SEA

Seán and Niamh Kennedy

THE O'BRIEN PRESS
DUBLIN

First published 2017 by The O'Brien Press Ltd.
12 Terenure Road East, Rathgar, Dublin 6, D06 HD27, Ireland.
Tel: +353 1 4923333; Fax: +353 1 4922777
E-mail: books@obrien.ie; Website: www.obrien.ie
The O'Brien Press is a member of Publishing Ireland.

ISBN: 978-1-84717-923-4

Design and layout by Tanya M Ross, www.elementinc.ie
Cover design: The O'Brien Press

Photographs:
p1 The Great South Wall; p3 Forty Foot steps; pp4-5 Howth
Head, looking south to County Wicklow; p6 The North Bull
Lightbouse; pp8-9 Rocky coast at Dalkey.

Cover images:
Front cover: View from Sandymount Beach; front flap: Dún
Laoghaire; back flap: Sailing off Dún Laoghaire; Back cover:
clockwise from top left: Stormy seas off the Great South Wall;
Bray to Greystones cliff walk; view south from Howth Head;
Dublin Port skyline.

Map on page 6: Tanya M Ross. www.elementinc.ie
Cover photographs: Seán Kennedy

6 5 4 3 2 1
20 19 18 17

Printed and bound by Drukarnia Skleniarz, Poland.
The paper in this book is produced using pulp from
managed forests.

Special thanks to Gordon Snell for permission to quote
Maeve Binchy on Dalkey, and Roddy Doyle for permission
for the quotation about Dublin Bay on page 1.

Dedication
For Mary Kennedy, wife & mother.
For all your support and endless encouragement.
This book wouldn't have happened without you.

Published in

DUBLIN
UNESCO
City of Literature

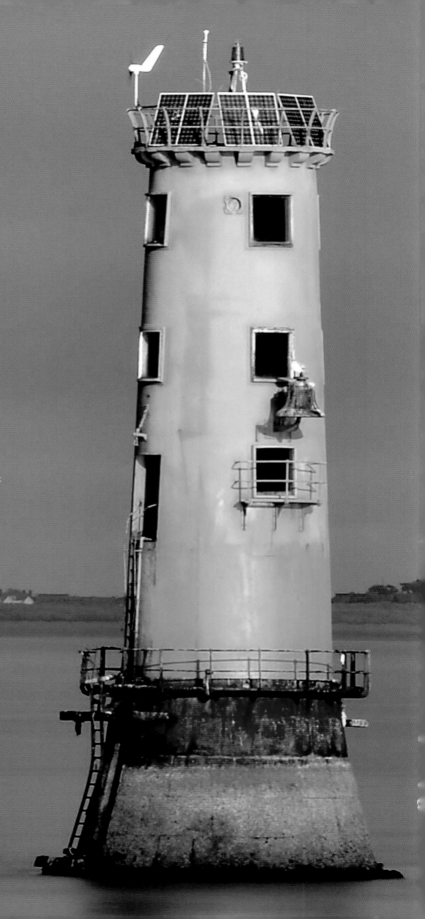

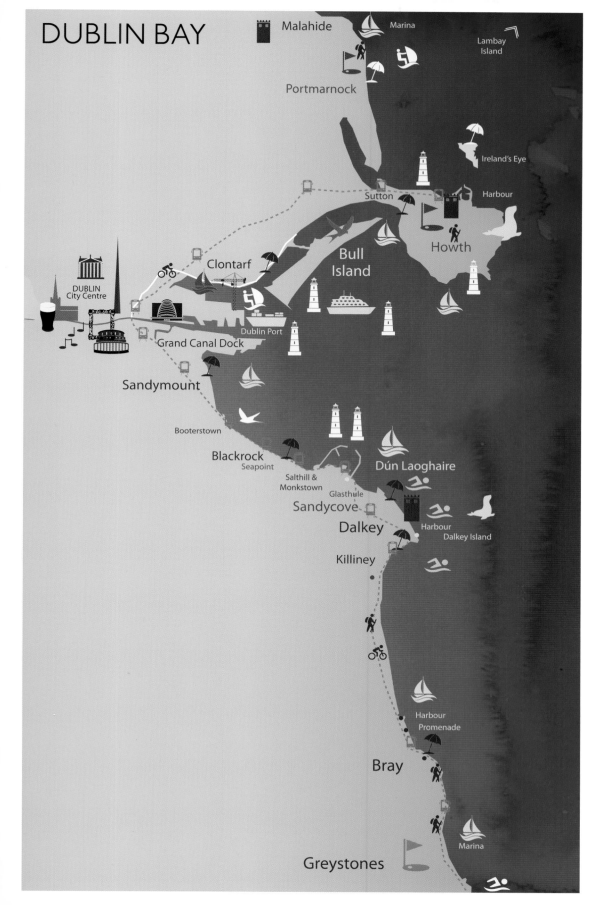

DUBLIN BAY

Malahide
Marina
Lambay Island
Portmarnock
Ireland's Eye
Sutton
Harbour
Howth
Bull Island
Clontarf
DUBLIN City Centre
Grand Canal Dock
Dublin Port
Sandymount
Booterstown
Blackrock
Seapoint
Salthill & Monkstown
Glasthule
Dún Laoghaire
Sandycove
Dalkey
Harbour
Dalkey Island
Killiney
Bray
Harbour
Promenade
Greystones
Marina

GOLFCOURSE

BEACH

SAILING

WALKS

DART

DUBLIN CITY CENTRE

ART GALLERIES

MUSEUMS

LIVE MUSIC

GUINNESS STOREHOUSE

CATHEDRALS

GPO

THE SPIRE

THE CONVENTION CENTRE

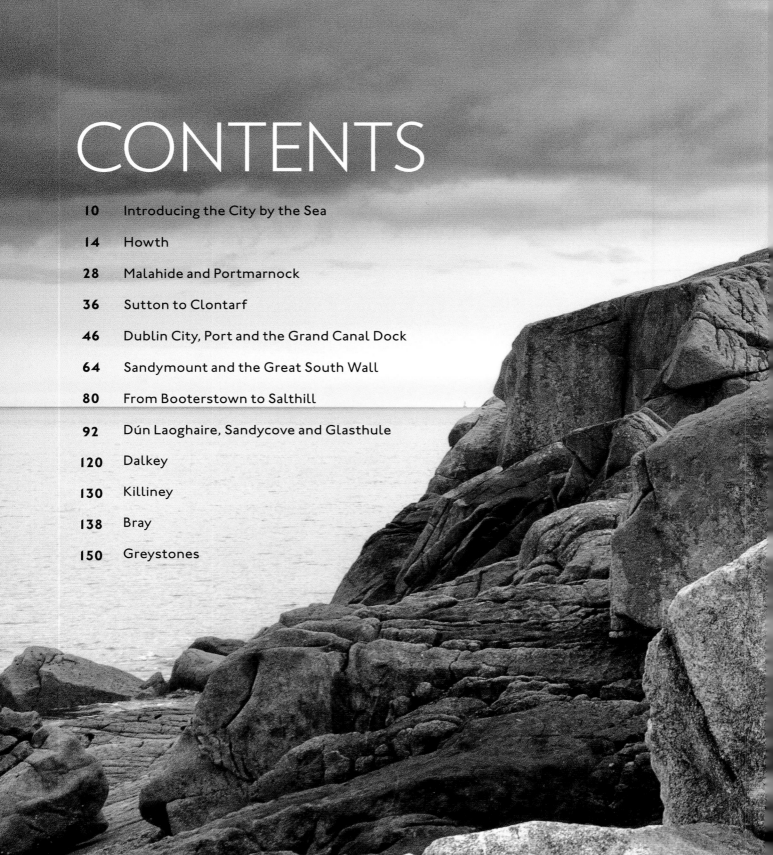

CONTENTS

from swerve of shore to bend of bay

James Joyce, *Finnegans Wake*

INTRODUCING THE CITY BY THE SEA

The majestic Dublin Bay runs for 30 kilometres from Howth Head in the north to Dalkey Island in the south on Ireland's east coast. Sandy beaches, rocky shorelines, dramatic cliffs, island retreats, salt marshes and mud flats are some of the diverse habitats that make up Dublin Bay. Steeped in history, with an abundance of wildlife and a rich cultural heritage, the bay area has much to offer locals and visitors alike. The DART (Dublin Area Rapid Transit railway) is a local railway that snakes its way around the bay, linking the many small villages and harbour communities and offering easy transport to and from the city centre. The DART route also takes in the picturesque and historic towns of Malahide and Portmarnock to the north and Bray and Greystones to the south, and so, whilst not technically part of Dublin Bay, they have been included in this book.

Dublin Bay has been the backdrop to numerous infamous incidents in Irish history. It was at the Battle of Clontarf in 1014 that Brian Boru, High King of Ireland, emerged victorious over the Vikings. Many of the villages and towns around the bay area, such as Howth and Dalkey, can trace their histories back to Viking and Norman invasions. The bay has also been the scene of over 600 shipwrecks. The sinking of the *Prince of Wales* and *Rochdale* ships in 1807, with a total loss of 400 lives, led to the construction of the harbour at Dún Laoghaire. The biggest single loss of life in Irish waters occurred in October 1918, just four nautical miles, around seven and a half kilometres, off the coast of Dún Laoghaire, when the RMS *Leinster* was torpedoed by a German submarine, resulting in over 520 people losing their lives.

Another reminder of the rich history of this area are the numerous castles dotted around the bay. The castle at Howth has remained in the same family for hundreds of years and is still inhabited today. Many of these castles are open to the public, such as those at Malahide and Dalkey. Some have been redeveloped as hotels, including Clontarf Castle and Fitzpatricks in Killiney, and offer people the opportunity to experience a little of castle life for themselves.

A frequent sight around the bay area are the Martello towers. These striking round towers were built as part of the British defence against the French during the Napoleonic era. There were 50 Martello towers built in Ireland with 21 of them in the Dublin Bay area. These bomb-proof forts had 2.5-metre thick walls. The ground floor housed ammunitions; the first floor sleeping quarters, and the parapet sported a canon. Some of the Martello towers have fallen into disrepair; however, a number have been restored and are open to the public. The most famous Martello tower is arguably the one at Sandycove, which was briefly home to James Joyce. It has been redeveloped and now houses a museum dedicated to the writer's works.

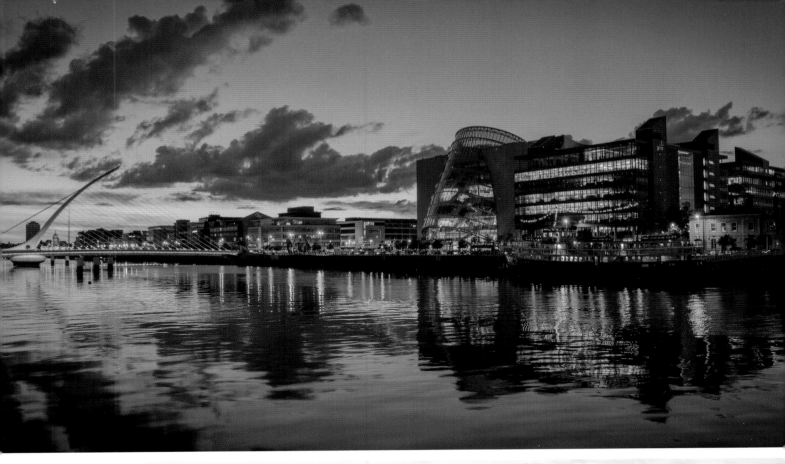

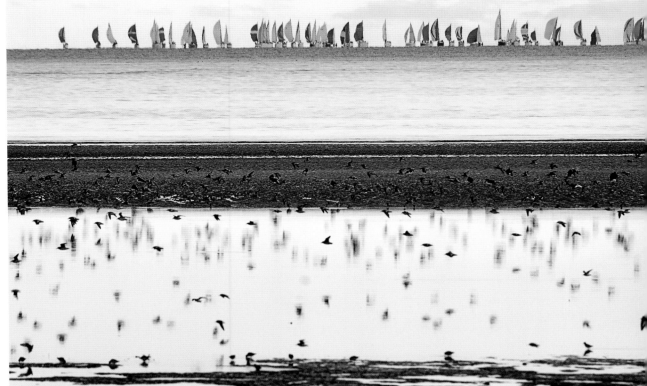

Top: The **River Liffey** at dusk.

Bottom: Sailing in **Dublin Bay**.

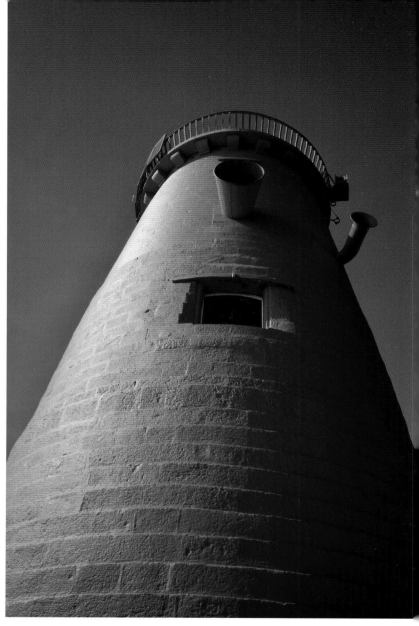

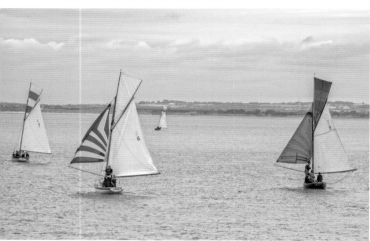

Clockwise from top left:
The clocktower at **St Anne's Park**, Clontarf;
Poolbeg Lighthouse; Seapoint's **Martello tower**;
Howth 17s, the treasured, oldest, one-design,
gaff-rigged keelboats in the world.

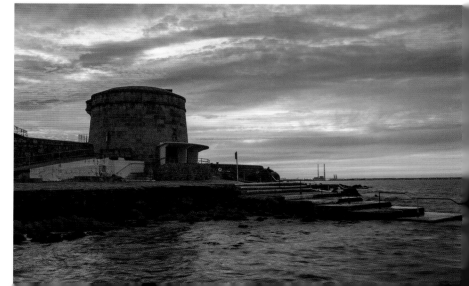

One cannot talk about Dublin Bay without mentioning its rich literary heritage. The bay was itself a character in James Joyce's *Ulysses* and this is brought to life every year on 16 June, Bloomsday. Other highlights on the literary calendar include the Mountains to the Sea festival in Dún Laoghaire and the Dalkey Literary Festival. The villages and towns around Dublin Bay have been, and still are, home to numerous literary legends: James Joyce, WB Yeats, Seamus Heaney, Bram Stoker, Oscar Wilde, Roddy Doyle, Maeve Binchy, Anne Enright and Marian Keyes, to name but a few. The sweeping coastline has provided solace and inspiration to a variety of artists over many generations.

Dublin Bay is also home to an abundance of wildlife. In 1981 the area of North Bull Island was recognised by UNESCO as a unique biosphere due to its diverse wildlife and habitats. This designation was extended to include the whole bay in 2015. Brent geese escape the harsh Canadian Arctic winter by migrating to Dublin Bay, and can be spotted from November on the mudflats at Booterstown and by Greystones South Beach. There is also a healthy seal (Common and Grey) population around the coast, often to be seen at the harbours of Howth and Dalkey.

Where the River Liffey meets the sea, at the centre of the bay, is the modern port of Dublin. Dublin Port came to be at its current location following the construction of the South Wall in 1715 and later the North Wall in 1842, both of which were put in place to alleviate silting. Today the Docklands area is a vibrant hub of modern commerce. The evolution of a city with a young, cosmopolitan population is reflected in the contemporary architecture on display along the quays.

Watersports enthusiasts are well served by Dublin Bay. For the sailor, there are several yacht and boat clubs, including Dún Laoghaire's the Royal Irish Yacht Club, established in 1831, the Royal St George Yacht Club of 1838 and the Royal Alfred Yacht Club, established in 1857. The National Yacht Club, dating from 1870, is also in Dún Laoghaire, and is the homebase of Olympic medalist Annalise Murphy; other thriving clubs include Howth, Malahide, Bray and Greystones. The various strands and beaches around the bay, such as 'The Velvet Strand' in Portmarnock, Dollymount Strand and Sandymount, provide a perfect environment for other watersports, including kite- and windsurfing, kayaking, rowing and fishing, as well as being popular with families, walkers, runners, horseriders and nature enthusiasts.

If golf is more your style, a round-with-a-view can be enjoyed at the world-renowned links course at Portmarnock. Bull Island has not one but two golf courses on offer.

The Dublin Bay area can be easily enjoyed by public transport but is possibly best experienced on foot or by bicycle along the well-marked walk-ways and bike paths. The bay flows from village to village, each with their own unique feel and history. Fish and chips on the pier in Howth, a pint in 'The Sheds' in Clontarf or The Harbour Bar in Bray, a 99 ice cream from Teddy's in Dún Laoghaire – these are all Dublin institutions.

The photographs in this book capture the built heritage, varied landscapes, seasons, moods, seaside cultural highlights and, above all, the ever-changing sweep of the waters and skies of Dublin Bay.

> The summer evening had begun to fold the world in its mysterious embrace.
> Far away in the west the sun was setting and the last glow of all too fleeting day
> lingered lovingly on sea and strand, on the proud promontory of dear old Howth
> guarding as ever the waters of the bay

James Joyce, *Ulysses*

HOWTH

The village of Howth, located on the Howth Head peninsula, forms the northern boundary of Dublin Bay. Fifteen kilometres from Dublin's city centre, it can be easily reached by public transport. A cycle path runs along the coastline from the city centre, and the relatively flat terrain makes it a pleasant cycle for even an inexperienced cyclist.

Howth is an area steeped in history. In 819 Norse Vikings arrived on its shores and in 1177 fell to the Normans. Howth Castle, Ireland's oldest occupied building, was built by Almeric St Lawrence, Baron of Howth, in the late 12th century. Originally constructed of wood, the current castle came into being in 1738 and remains home to descendants of its original occupant.

The Howth area boasts four Martello towers, one each on the islands of Ireland's Eye and Lambay to the north of Howth Head, one at Red Rock in Sutton and the fourth overlooking Howth Harbour, which is open to the public and houses Ye Olde Hurdy Gurdy Museum of Vintage Radio, a cornucopia of radio nostalgia.

Howth has been a busy working port, dating back to the 14th century. It was famously used by Erskine and Molly Childers to land weapons, in their yacht the *Asgard*, for use by the Irish Volunteers against the British prior to the 1916 Rising and War of Independence. For many years, Howth hosted the mail boat from Britain, a frequent target for highway robbers. Today, it remains a bustling fishing port and boasts many great bars and restaurants where one can sample the local catch-of-the-day. The harbour is also popular with seals, who can regularly be spotted in and around the fishing boats.

The wild, hilly headland of Howth Head, with its gorse and heather, is home to abundant wildlife and is a designated as a special area of conservation under the EU's Habitat Conservation. As you make your way along one of the many signposted walking trails across the head, the words of Molly Bloom remembering Leopold's proposal in *Ulysses*, may well sound on the wind:

> the sun shines for you he said the day we were lying among the rhododendrons
> on Howth head in the grey tweed suit and his straw hat the day I got him to
> propose to me

From the bustling harbour, you can walk along the cliff-face, taking in views of Lambay Island, Ireland's eye and the Baily Lighthouse, before enjoying a well-deserved drink in the 'The Summit' pub.

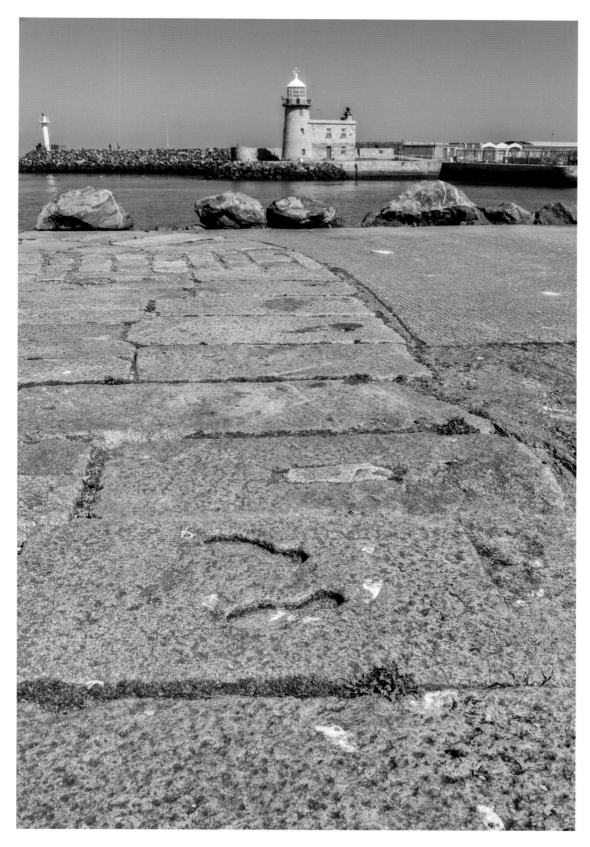

The most famous 19th-century arrival to Howth was **King George IV**, who visited Ireland in 1821 and is chiefly remembered because he staggered off the boat in a highly inebriated state. He did manage to leave his footprint at the point where he stepped ashore, and the imprint of his footsteps were cut into the landing stone at the time and can still be seen at the end of the West Pier.

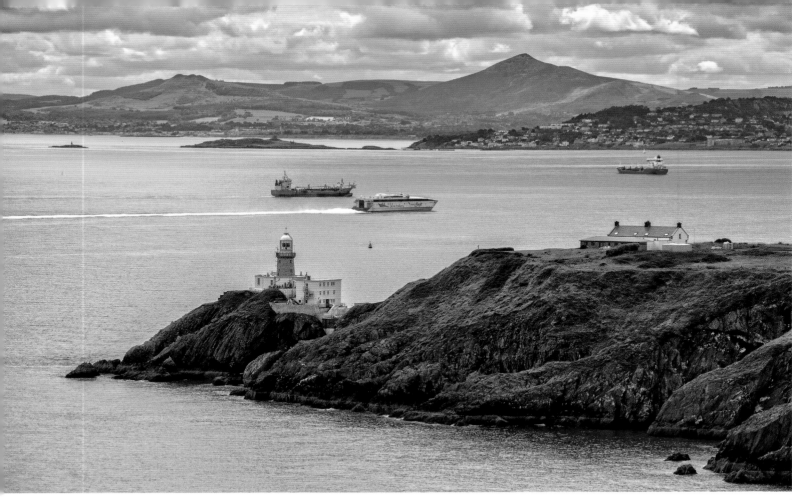

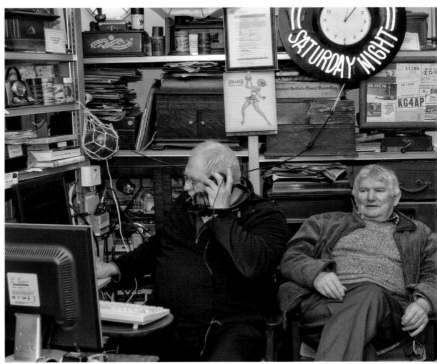

Top: View from the **Howth Head cliff walk** over Dublin Bay to Dalkey Island and beyond to the Sugar Loaf mountain in County Wicklow. The ferry sails in from Holyhead in Wales, and the cottage-style lighthouse of the Baily is perched on the end of the promontory.

Bottom: Curator **Pat Herbert** relaxing at the Hurdy Gurdy Museum of Vintage Radio in the Martello tower, Howth, home to a vast collection of radios, gramophones and other radio-related paraphernalia. The tower was once the terminus of the first telegraph connecting Wales to Ireland in 1852. Pat and his volunteers provide tours. The museum also has an amateur radio station.

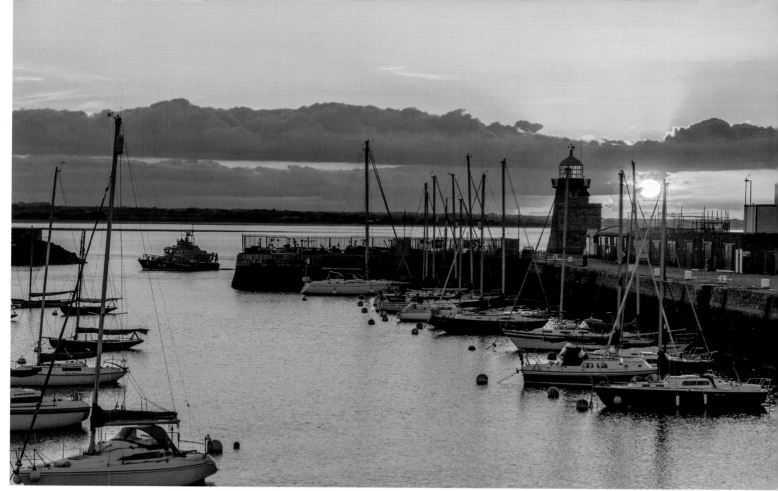

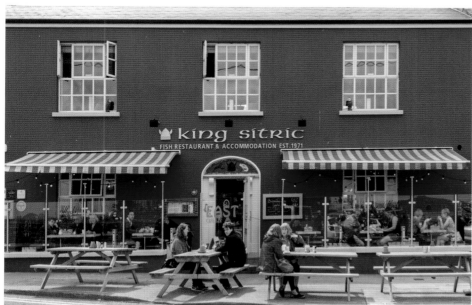

Top: The **RNLI lifeboat** returning to Howth Harbour as the sun dips below the horizon out to sea. Visiting yachts and yachts from Howth Yacht Club are moored for the night, as classes come to an end for another day.

Bottom: The **Kíng Sítríc** fish restaurant in Howth is famed for its seafood. Howth is home to welcoming pubs and restaurants, many serving local Dublin Bay prawns.

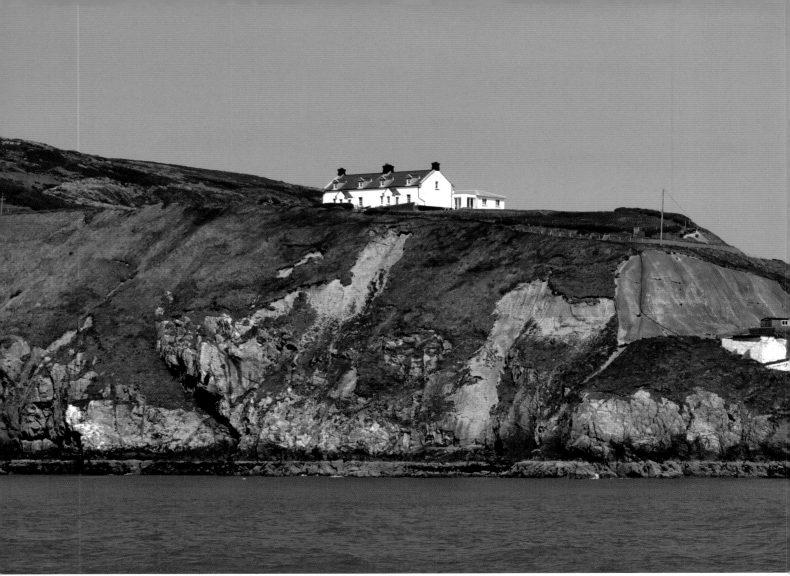

Top: The **Baily Lighthouse** photographed from the Dublin Bay Cruise boat that sails between Dublin City, Dún Laoghaire and Howth between April and October. Completed in 1814, the Baily Lighthouse is maintained by the Commissioners of Irish Lights. The top of the tower stands 134 feet (41 metres) above the sea. In 1996 the lighthouse was converted to automatic operation. A small museum is open by arrangement.

Bottom: Early morning activity at the entrance to **Howth Harbour**. Sailing is hugely popular all around the Irish coast. In the Dublin Bay area there are clubs at Malahide, Howth, Sutton, Clontarf, Ringsend, Dún Laoghaire, Bray and Greystones. The sailing competition season runs from April to the end of September, but there is activity all year, weather permitting.

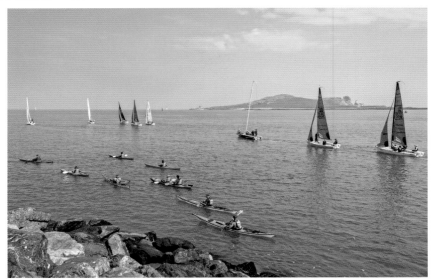

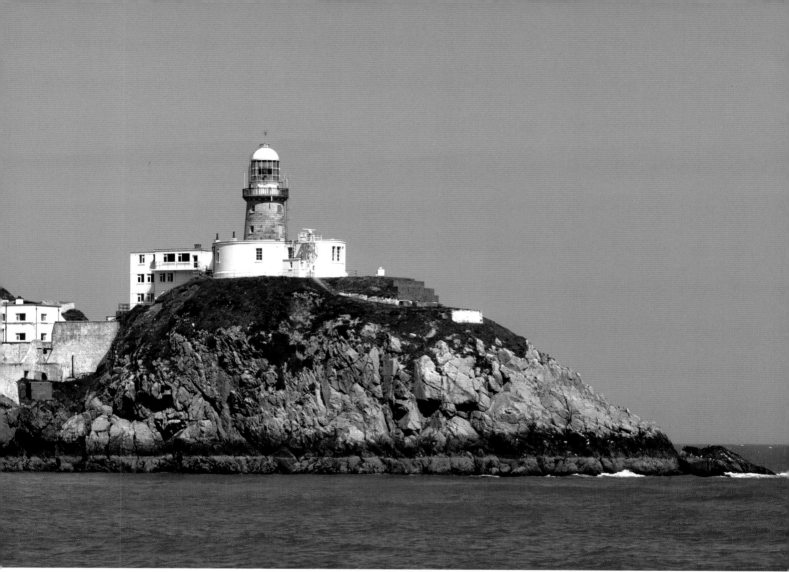

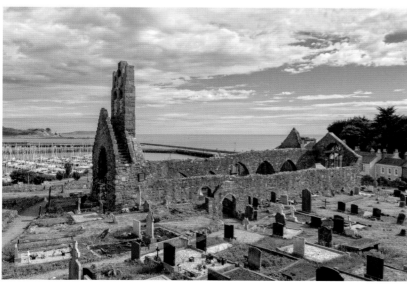

Bottom: St Mary's Abbey, Howth, was built in 1235 on the site of an earlier 11th-century church. Modified in the 14th, 15th and 16th centuries, the St Lawrence family of Howth Castle added a private chapel with burial tomb at the east end. The abbey affords one of the best views in Howth. The nearby Abbey Tavern is famed for its Irish music sessions.

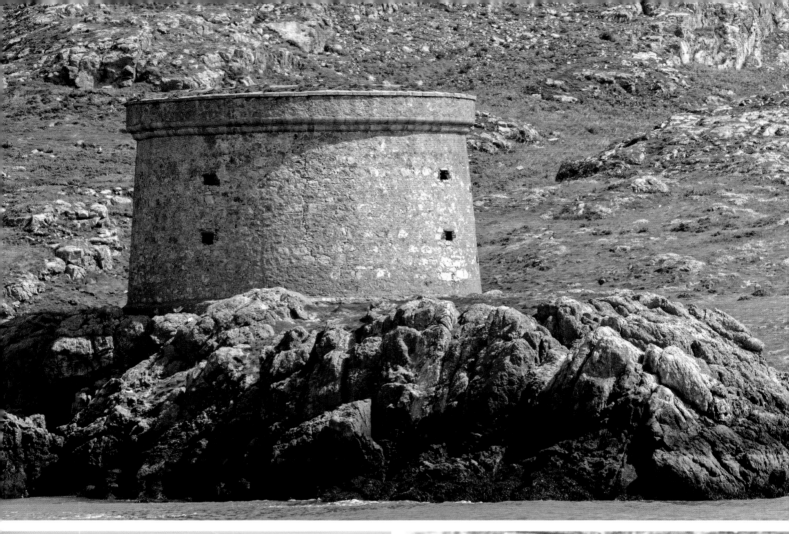

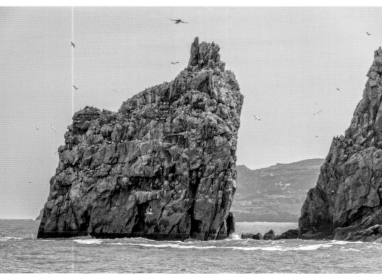

Top: The **Martello tower** on Ireland's Eye is one of over twenty built in the Dublin Bay area, in the early 19th century, to defend against feared attacks from France. **Bottom left: The Stack** on Ireland's Eye. Large numbers of guillemots, terns, gannets, razorbills, cormorants and puffins nest around the shore. The whole island is now a bird sanctuary. **Bottom right:** Starlings drying off in Howth.

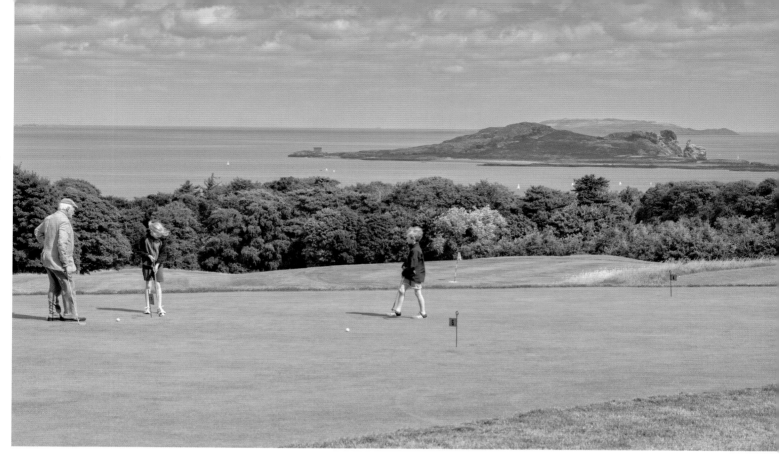

Top: Deer Park Golf Club is set against the magnificent backdrop of Howth Castle with stunning views of the Dublin coastline. The two islands in the background are Ireland's Eye, known for its bird sanctuary, and, in the distance, Lambay Island, the largest island off the east coast of Ireland.

Bottom: The National Transport Museum of Ireland is based in the grounds of Howth Castle. With exhibits dating back to 1883, the collection is divided into five main categories: passenger; commercial; fire and emergency; and military and utility.

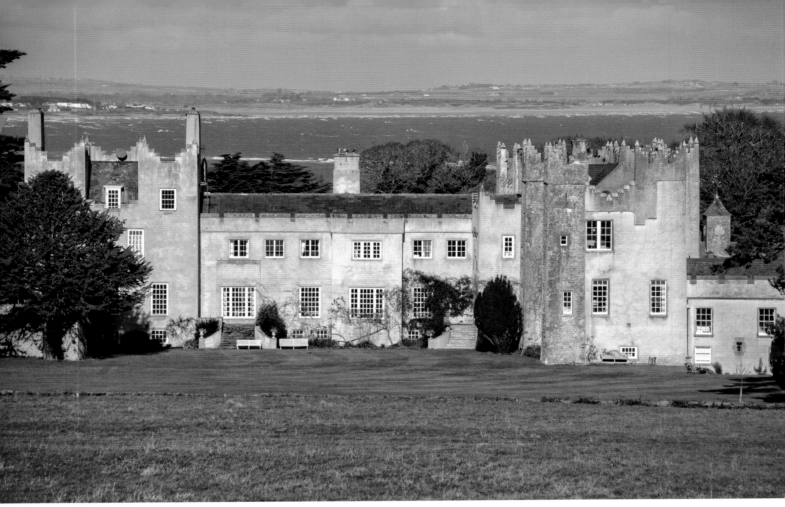

Top: Since 1180 the St Lawrence family have been the Lords of Howth and resided at **Howth Castle**. Popular legend has it that, in 1576, the pirate Grace O'Malley (Granuaile) attempted to pay a courtesy visit to the 8th Baron Howth. However, she was informed that the family was at dinner and the castle gates were closed against her. In retaliation, she abducted the grandson and heir. He was released when a promise was given to keep the gates open to unexpected visitors, and to set an extra place at every meal. This agreement is still honoured today.

Bottom: A fishing vessel passing **Ireland's Eye**. Howth also offers pier, rock and boat fishing for anglers, with whiting, pollack and mackerel forming some of the catch.

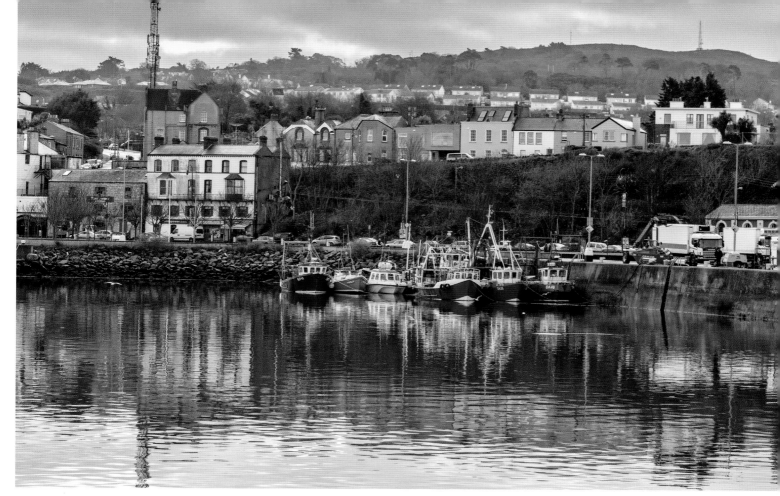

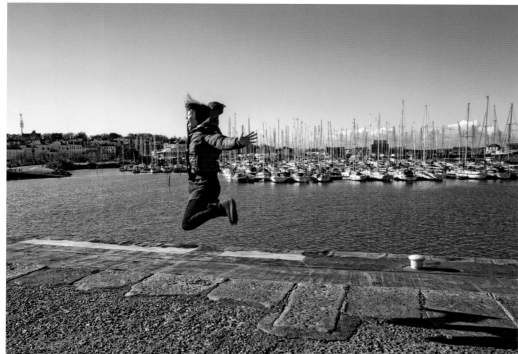

Top: Looking back at the colourful houses of **Howth** from the middle pier.

Bottom: Jumping for a photo, with **Howth Harbour**, **Yacht Club** and **Marina** in the background.

A boat passing **Ireland's Eye** in early May with the island covered in bluebells. The beautiful display of colour is due to the island being scorched by gorse fires the previous year.

Top: The **Kish Bank** is a shallow sandbank about 11 kilometres off the coast. Throughout the 19th and early 20th centuries the shallows claimed many lives. Today the dangers are marked by the Kish Lighthouse, a landmark well known to sailors and ferry passengers passing through Dublin Bay.

Bottom: Howth Yacht Club started out as Howth Sailing Club in 1895. Howth Sailing Club later combined with Howth Motor Yacht Club to form Howth Yacht Club. Club member, and former taoiseach, Charles Haughey lobbied to secure State funds to redevelop Howth Harbour as a major fishing port and sailing destination. The state-of-the-art sailing club was key to the resurgence of Howth.

"
And far on Kish bank the anchored lightship twinkled

James Joyce, *Ulysses*

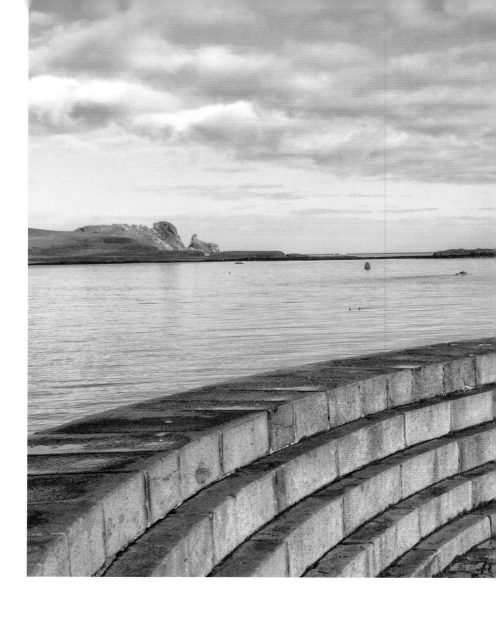

Top: The curved stonework of the **West Pier**. Howth was a trading port from at least the 14th century, although the harbour was not built until the early 19th century. The harbour was radically rebuilt in the late 20th century, with the formation of distinct fishing and leisure, and the installation of a modern ice-making facility. A new lifeboat house was later constructed, and Howth is today home to both the RNLI (lifeboat service) and the Irish Coastguard.

Right page, bottom: This view, from St Mary's Abbey, shows the harbour to its best advantage, with the **East Pier**, the **lighthouse** and the two largest islands close to Ireland's eastern coastline, **Ireland's Eye** and **Lambay**. The marina is owned by Howth Yacht Club and welcomes visiting yachts.

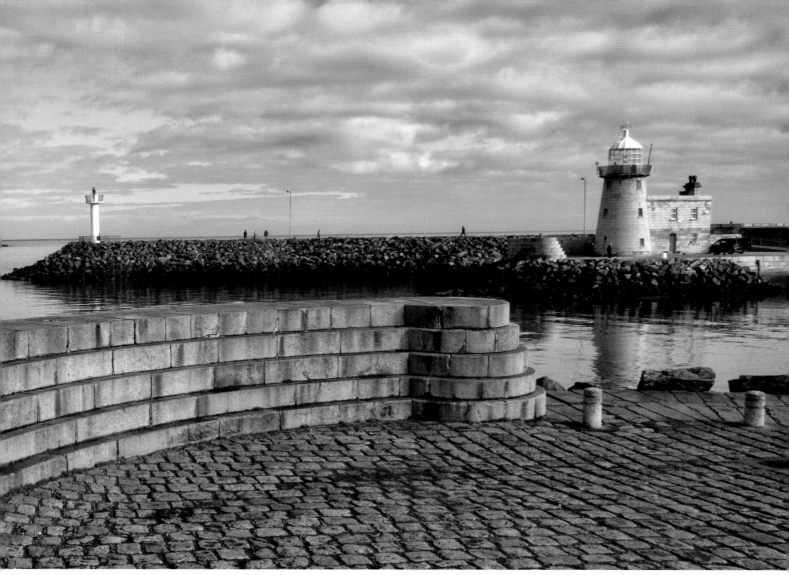

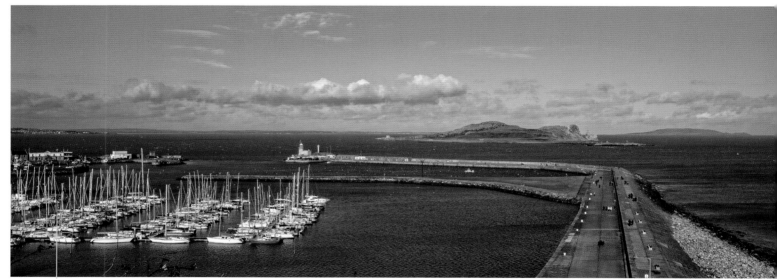

MALAHIDE AND PORTMARNOCK

The coastal town of Malahide was another area to fall victim to Viking invasion in the 8th century. Malahide Castle was first built by the Talbot family, who held the title of Earls of Shrewsbury in the late 12th century, and their descendants remained in residence there until 1975. The castle was extensively extended during the reign of Edward IV, in the 17th century, with the addition of the distinctive towers which lend the castle its fairytale appearance. The castle sits on a 260-acre (105-hectare) estate, including 22 acres (9 hectares) of ornamental gardens, created by Lord Milo Talbot, the last Lord Talbot to reside in Malahide Castle. The castle and gardens are open to the public.

Georgian times saw Malahide become a seaside retreat for well-to-do Dubliners and as a result some fine examples of Georgian architecture can be seen, especially along the seafront. Malahide remains a popular suburb and a bustling village with many fine restaurants, especially around the water's edge. Gibney's pub, on New Street, has been in the same family for four generations and is a favourite with locals and visitors alike.

Fans of watersports, including windsurfing, kite-surfing and sailing, are well served by the Malahide estuary and the River Broadmeadow estuary, which lies just to the east of Swords. The Malahide Yacht Club has two clubhouses and the two estuaries, providing two distinct sailing waters. The Broadmeadow Water's non-tidal conditions are perfect for dinghy sailing, racing and learning to sail.

Malahide cricket club is Ireland's biggest cricket venue and home to Ireland's international cricket team. Founded in 1879 Malahide Lawn Tennis and Croquet Club, in Malahide village, is one of the oldest in Ireland.

For those looking to explore the coastline, a 4-kilometre, elevated costal pathway takes you from Malahide, south to the village of Portmarnock, with its beautiful sandy beach, known coloquially as 'The Velvet Strand'. The beach was the starting point for the first solo westbound transatlantic flight in 1932, this and other transatlantic adventures, for which Portmarnock was the embarkation point, are commemorated by the Southern Cross sculpture, 'Eccentric Orbit' by Rachel Joynt, on the seafront.

Portmarnock is also widely known for its world-class links golf course, which has been home to the Walker Cup (1991) and has also hosted the Irish Open on numerous occasions.

Both Malahide and Portmarnock are easily accessible via public transport from Dublin and are stops on the DART line.

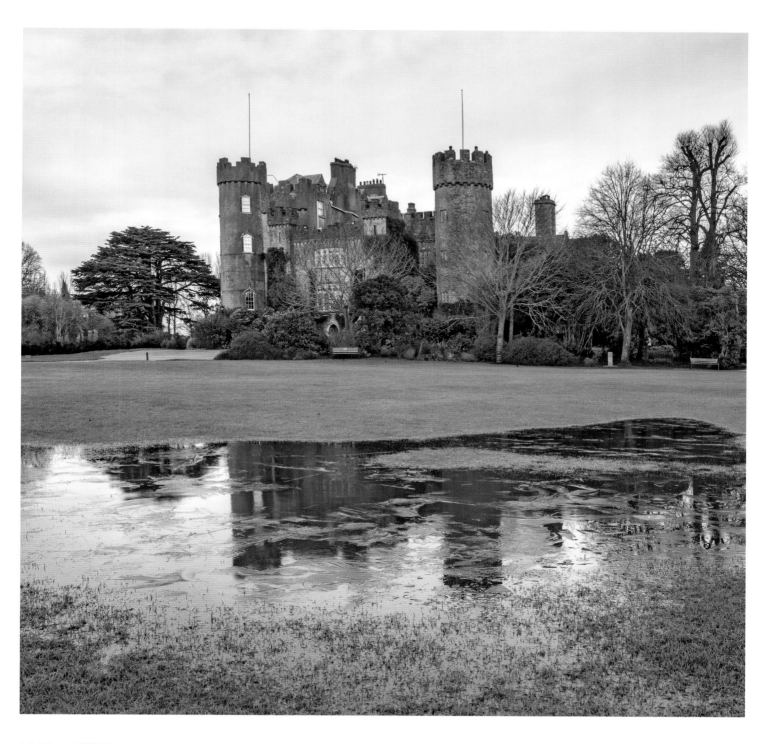

MALAHIDE

Malahide Castle, which dates from the 12th century, is situated beside the village of Malahide. In 1185 Henry II granted lands to the knight Richard Talbot. Today, the demesne is owned by Fingal County Council; Shannon Heritage manages the castle and parkland, and Avoca Handweavers have a restaurant and shop on site. The Talbot Botanic Gardens, comprising several hectares of lawns, a walled garden, seven glasshouses, and a Victorian-period conservatory, are situated behind the castle. The park contains a cricket ground, football pitches, a 9-hole golf course, a pitch-and-putt course, tennis courts and a boules area, as well as the nearby playground.

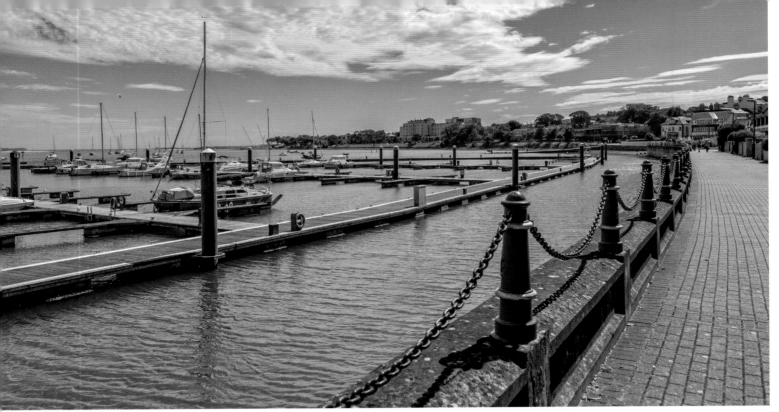

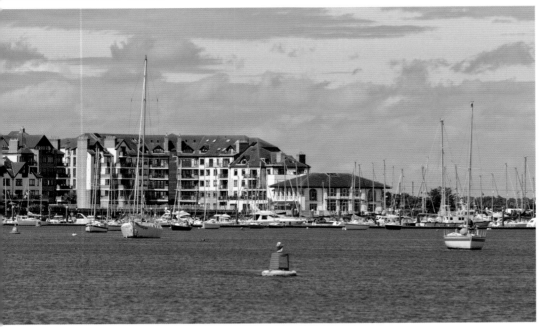

Top: A land view of **Malahide Marina**, with its walkway to the village. The marina entices the maritime visitor with its fully equipped boatyard and marine centre, and easy access to the attractions of the 'Village', as Malahide is known locally. **Bottom left:** Approaching **Malahide Marina Village** from the sea. Set inside the sheltered Broadmeadow Estuary, the marina is the ideal location from which to enjoy sailing. There are two sailing clubs situated on the estuary, Swords Sailing and Boating Club and Malahide Yacht Club. Entering and leaving Malahide by yacht is dependent on the tide, as the local sandbank proves a potential danger. **Bottom right:** **Malahide Village**.

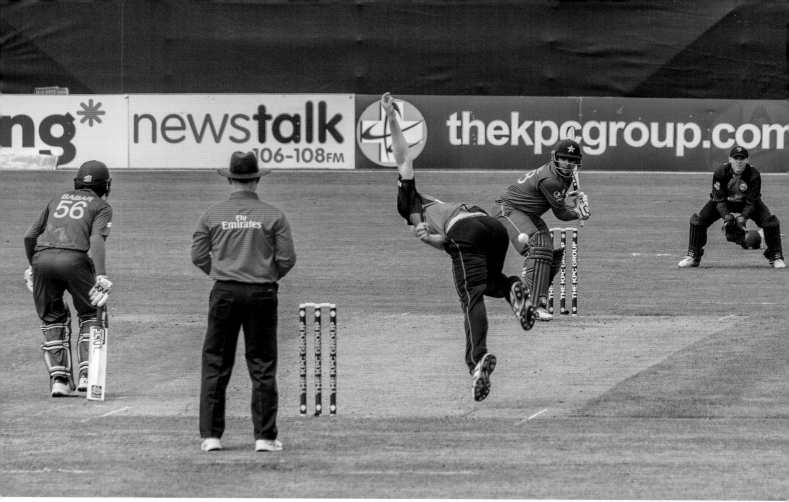

Top: Ireland playing against Pakistan at the **Malahide Cricket Club Ground**. The MCC was founded in 1861 and is in the grounds of Malahide Castle. In September 2013 the International Cricket Council cleared the ground to host international cricket. It has a capacity of 11,500, making it Ireland's biggest cricket venue.

Bottom: Old road marker outside **Malahide train station**.

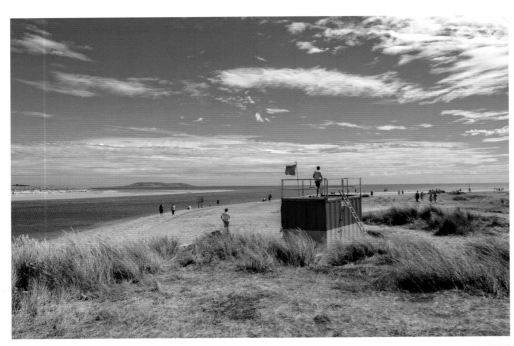

Top: Lifeguard on duty at **Malahide Beach** – an ideal spot for families as it is rarely packed, provides easy parking and has numerous rock-pools and sand dunes to explore. The sea-life that is washed up on shore is amazing to find; and pretty seashells abound.

Bottom: Townyard Lane, Malahide, Malahide village retains its village charm, while offering an extensive range of shops, with a small shopping centre, and a wide selection of pubs and restaurants and the Grand Hotel.

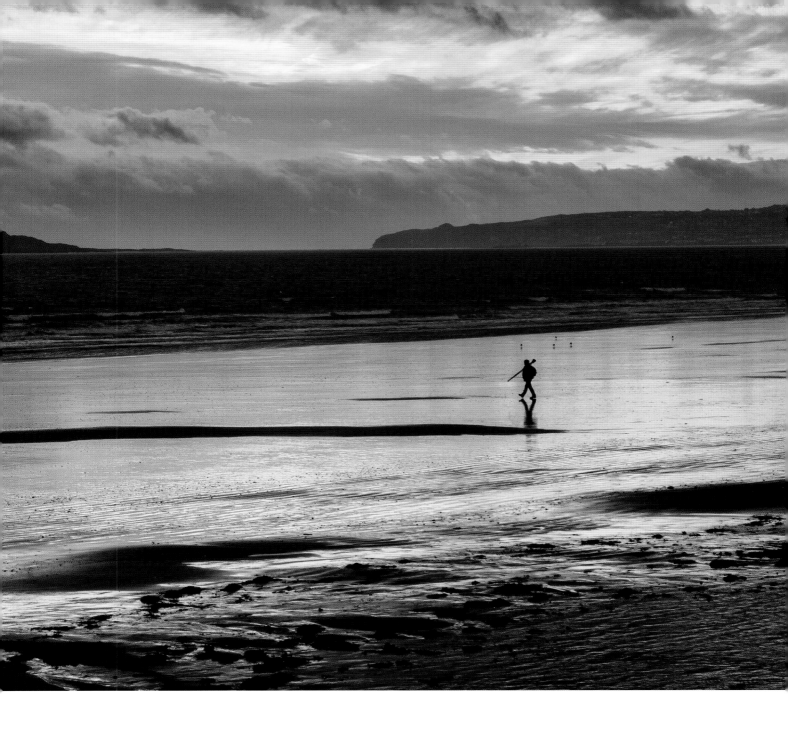

PORTMARNOCK

First light, looking towards the island of Ireland's Eye and Howth Head from '**The Velvet Strand**', Portmarnock.

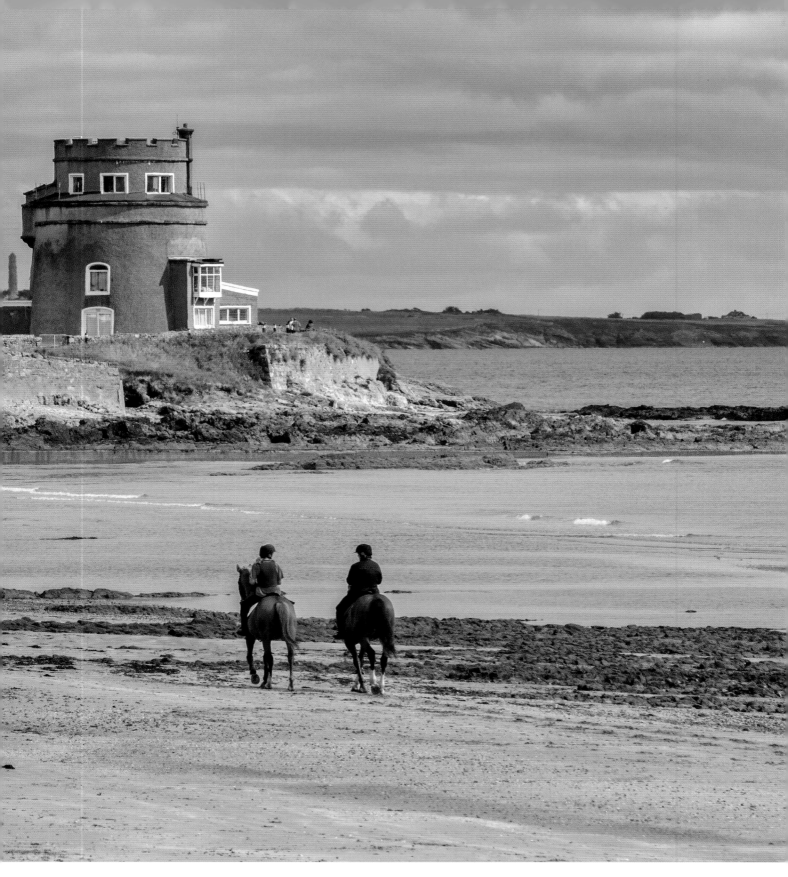

Left page: Portmarnock Beach with its converted Martello tower. The leisurely 4-kilometre walk from Malahide to Portmarnock Beach follows the beautiful coastline and provides tempting places to stop for coffee on the way. Portmarnock's beach is called 'The Velvet Strand' due its soft, smooth sands. The beach is ever popular with wind- and kite-surfers, swimmers and horse riders. Nearby, the internationally repected, serpentine Portmarnock Links Golf Course offers up to 27 scenic and challenging holes.

Top: The tide moves quickly on all of **Dublin Bay beaches**; this couple went in for a swim but had to rush back out of the water to save their chairs.

Bottom: '**The Velvet Strand**' was the starting point for two important pioneering flights. On 24 June 1930 Australian aviator Charles Kingsford Smith and his crew took off in the Southern Cross on the second, westbound transatlantic flight to Newfoundland. The first-ever solo East–West transatlantic flight began from this beach on 18 August 1932, when James Mollison, a Scottish pilot, took his de Havilland Puss Moth, Heart's Content, from Portmarnock to Pennfield, New Brunswick, Canada.

> Below us bay sleeping sky. No sound. The sky. The bay purple by the Lion's head.
> Green by Drumleck. Yellowgreen towards Sutton.

James Joyce, *Ulysses*

SUTTON TO CLONTARF

From the edge of the Howth Peninsula the bay winds its way through Sutton and on towards the Clontarf Road.

Sutton was home to the first Martello tower built on the north side of Dublin. Red Rock Tower, now a private residence, has been beautifully restored and is a fine example of the Martello towers that dot the coastline of Dublin Bay.

From here, one can enjoy a view of Bull Island, a man-made island that formed as a consequence of building the Bull Wall in the 1820s, to alleviate the problems of silting in Dublin Port. The island boasts two golf courses and one of north Dublin's most beloved beaches, Dollymount Strand. North Bull Island, as it is properly known, was designated a UNESCO Biosphere Reserve in 1981 and it is made up of beach, sand dunes, mudflats, grassland and marsh, providing habitats for numerous rare bird species, mammals, flora and fauna.

Dollymount Strand, 'Dollyer' to locals, is a 5-kilometre stretch of sandy beach. In bygone years it was where many people from this part of Dublin first learned to drive a car, although vehicle access is now restricted. In more recent times it has become a preferred spot for kite-surfing and is ever popular with walkers.

The island is linked to the mainland at Clontarf by a one-lane wooden bridge, Bull Bridge which has stood in place since 1906; it is also linked by a causeway at Raheny.

Back on the mainland, at the north-eastern corner of St Anne's Park, on the coast road, one can't help but be stopped in one's tracks by the intricate tree carving by Tommy Craggs. The piece, painstakingly carved from a Monterey Cypress tree, represents the creatures who live in the park and on nearby Bull Island. Other attractions in the park, which once formed part of the Guinness' estate, include an impressive rose garden and a weekly farmers' market in the beautifully restored Victorian stables.

From here you can follow the promenade, with its art deco shelters, along the water's edge through Clontarf. Clontarf's historical significance dates back to 1014 and the Battle of Clontarf, which saw the high king of Ireland, Brian Boru, emerge victorious over the Vikings. By the 18th century Clontarf was renowned for its fish-curing industry, and the infamous 'Sheds' can still be seen and lend their name to a local pub. Modern-day Clontarf is an affluent suburb with many fine restaurants and boutiques lining the coast road. Locals and visitors alike make good use of the walkways and dedicated bike paths that make this stretch of Dublin Bay so accessible.

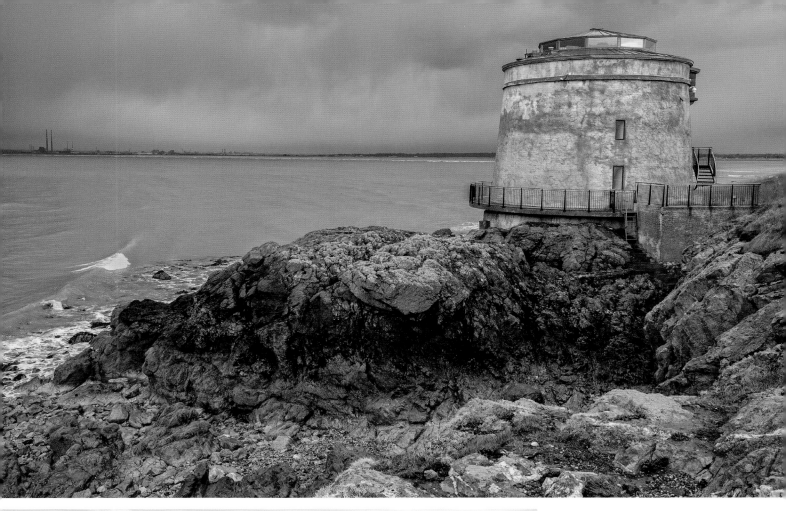

SUTTON

Top: Built in 1804, the **Martello tower** in Sutton is located on the north coastline of Dublin Bay. With wonderful views of the bay and Howth Head, it is the only Martello tower on the bay that you can rent out as self-catering accommodation. The gateway to this tower is a great place to start or finish a walk around Howth Head.

Bottom: This view to the south of Dublin Bay from the **Howth Head path** was taken while the northside was bathed in sunshine and the rain swept in to the south – the light was magical.

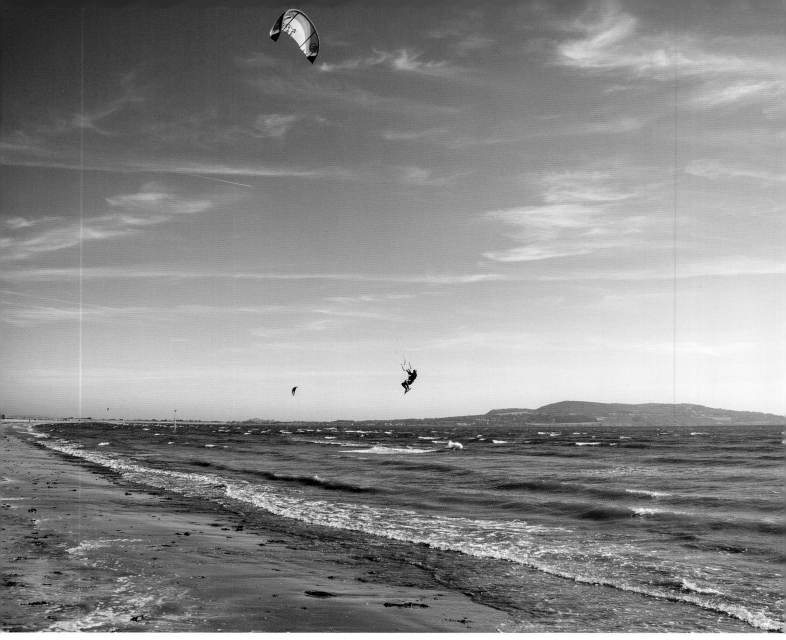

CLONTARF

Top: Kite-surfing on **Dollymount Beach**. This sandy beach and the dunes on Bull Island have been a playground for Dubliners since 1873 when a horse tram first ran to Clontarf.

Bottom: Bathing shelter on the **Bull Wall**. These Art Deco shelters were designed by Herbert Simms, a Dublin Corporation architect, in 1934.

Right page, top: Joggers running past a wind shelter on the **Clontarf promenade**.

Right page, bottom: Fishing is a popular activity in **Dublin Bay**, and lone figures can often be seen digging for bait at low tide.

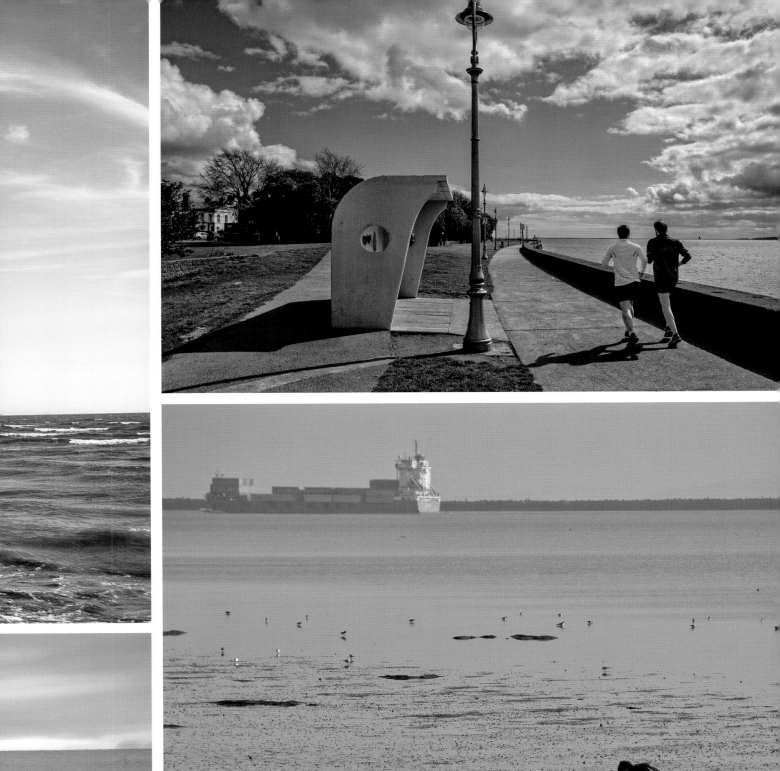
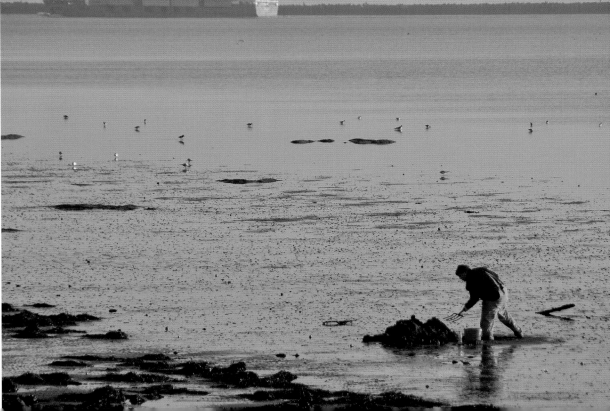

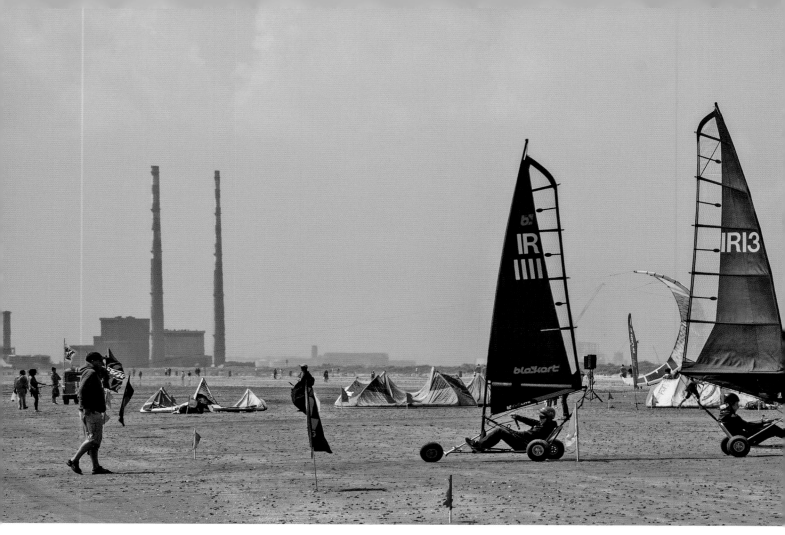

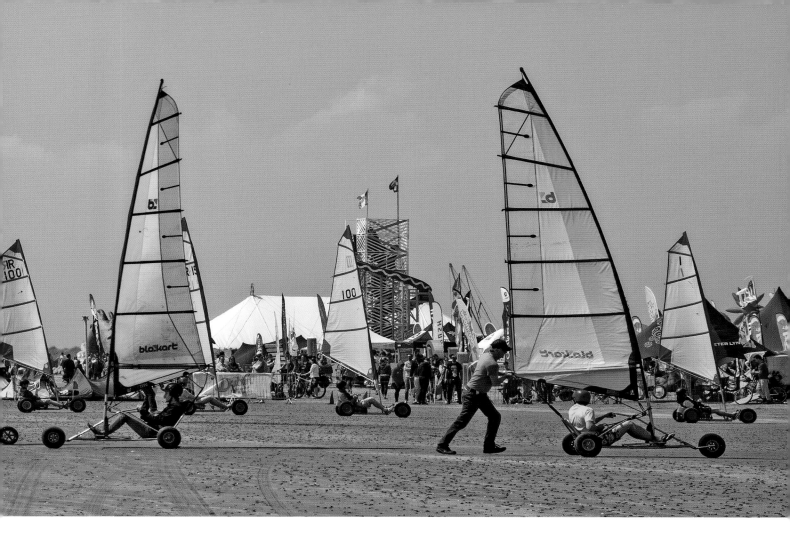

Top: Sandyachting is what it says — sailing on sand or land. **Dollymount Beach** is an ideal space for this activity.

Left page, bottom left: The Battle for the Bay is an annual festival of water and wind sports held there, bringing colour and life to the sands.

Left page, bottom right: Originally a fishing village and one of the early bathing places close to Dublin city, **Clontarf village** still has a cosy village atmosphere, with the sea to its front and St Anne's Park to the landside. Clontarf comes from the Irish *Cluain Tarbh*, meaning the 'meadow of the bull'. These days the village is part of Dublin's suburbs.

Top: The Gatehouse at **Clontarf Castle**. Built in 1837, Clontarf Castle Hotel has been enlarged with modern wings, but the gatehouse retains its charm.

Bottom: The Red Stables, St Anne's Park, the second largest park in Dublin. The park is a haven for walkers and joggers, with numerous pitches, a par-3 golf course and tennis courts. Each year thousands of visitors delight in its Rose Festival.

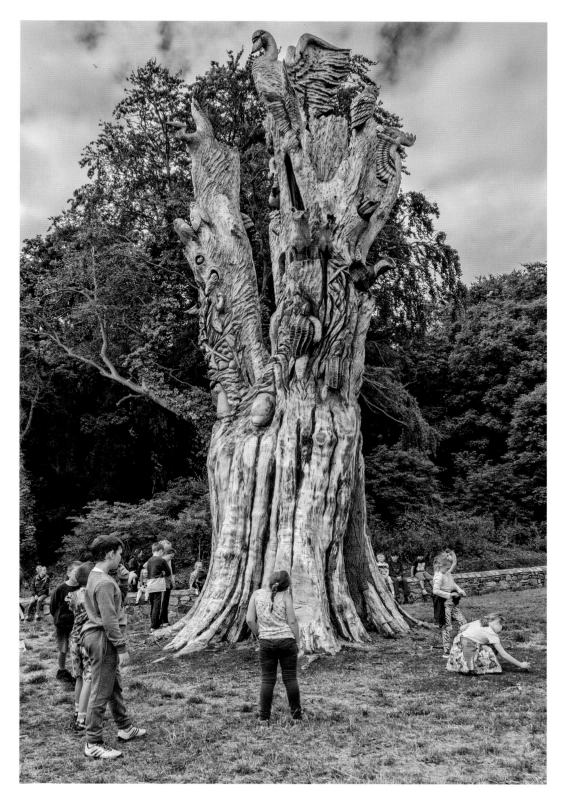

Tommy Craggs' **tree sculpture** beside the north-east corner of St Anne's Park. The carved woodland creatures and birds look out over the causeway road to Bull Island.

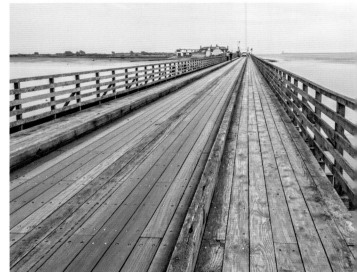

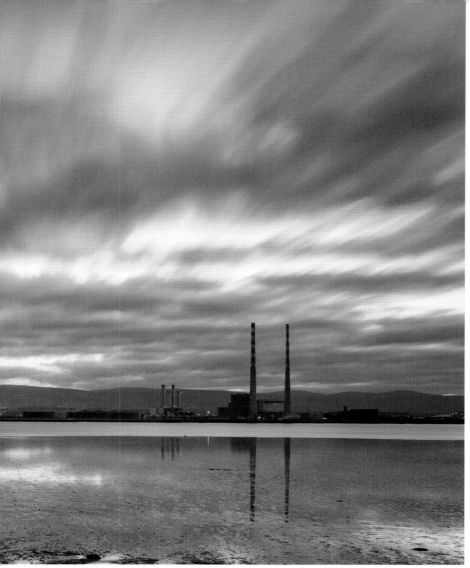

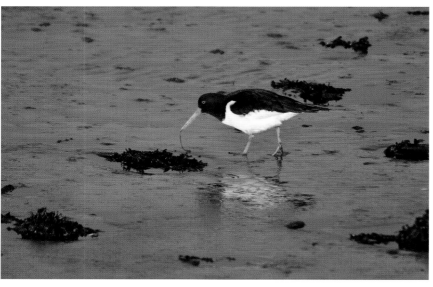

Left page, top: Streaks of luminous pinks and greys are captured by a slow shutter speed shot across **Dublin Bay**, just after sunset, from Bull Island.

Left page, bottom left: Early morning bike ride on the North Bull Wall, with a view back towards the **Dublin docks**.

Left page, bottom right: The wooden bridge linking **Bull Island** to **Clontarf**. The first Bull Bridge was erected in 1819 to facilitate the construction of the Great North Bull Wall, one of the two sea walls of Dublin Port.

Right page, top: A **stonechat** posing on a fence post on Bull Island.

Right page, bottom: The distinctive orangey-red bill and legs of an **oystercatcher** on the mudflats near Bull Island.

DUBLIN CITY, PORT AND THE GRAND CANAL DOCK

The area on either side of the Liffey where the river flows into Dublin Bay is known as the Docklands. In Viking and medieval times the main port of Dublin was located further upstream at Christ Church Cathedral, but with the construction of the South Wall in 1715 and the opening of the James Gandon designed Custom House in 1791 the business of the port moved further downstream. Following the building of the North Bull Wall in 1842 the port moved even further downriver towards its current location.

The Docklands area has seen a massive regeneration in recent years and numerous financial and technology firms have chosen to make the Dublin Docklands their home, leading to the south docks being referred to as the Silicon Docks.

What is most striking about this part of Dublin Bay is the modern architecture. The sculptural Samuel Beckett Bridge, by Spanish neofuturistic architect Santiago Calatrava, was designed to resemble a harp and rotates at a 90-degree angle to facilitate the passage of maritime traffic. The twinkling façade of the Grand Canal Theatre and the impressive cylindrical glass structure of the Convention Centre represent the evolution of the city in recent years.

However, among these contemporary architectural marvels some examples of the old Docklands industry survive. The CHQ building, a wine and tobacco warehouse, built in 1820, has been extensively restored. This venue was used to host a banquet to celebrate the return of 3,000 Crimean war veterans in 1856; today it houses shops, restaurants and an exhibition space, which encompasses EPIC Ireland. Further east, towards the mouth of the river, at the point where the East Wall meets the North Wall of the port, the 3Arena is another example of a former warehouse given new life. It was here that the internationally acclaimed rock bank U2 recorded some of the music for their Rattle and Hum album. The venue was extensively redeveloped in 2007/8 and is now the first venue of its size in Ireland that is custom designed for live music.

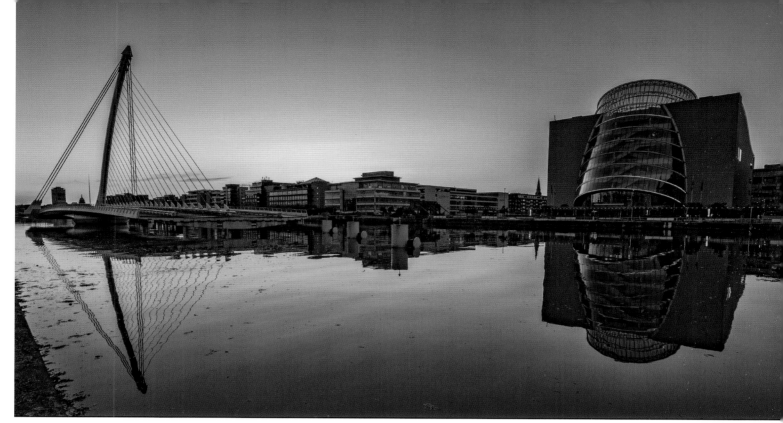

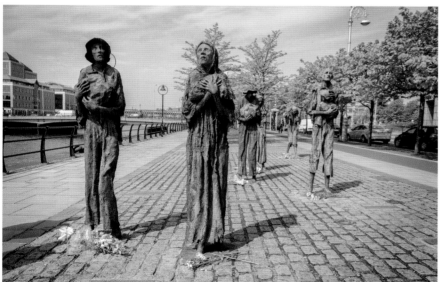

DUBLIN CITY AND PORT

Top: Last light on the Liffey silhouettes the landmark cylindrical **Convention Centre**, on Spencer Dock, and the sleek, asymmetric **Samuel Beckett Bridge**. Designed by Pritzker Prize-winning American-Irish architect Kevin Roche, the Convention Centre features a stunning glass-fronted, cylinder-shaped atrium, giving visitors panoramic views of the city and the mountains beyond. At night, the façade displays multi-coloured lights with occasional digital slideshows.

Bottom: The **Famine statues**, by artist Rowan Gillespie, on Custom House Quay, commemorate Ireland's Great Famine of the mid-19th century, when a million people died and a million more were forced to leave Irish shores.

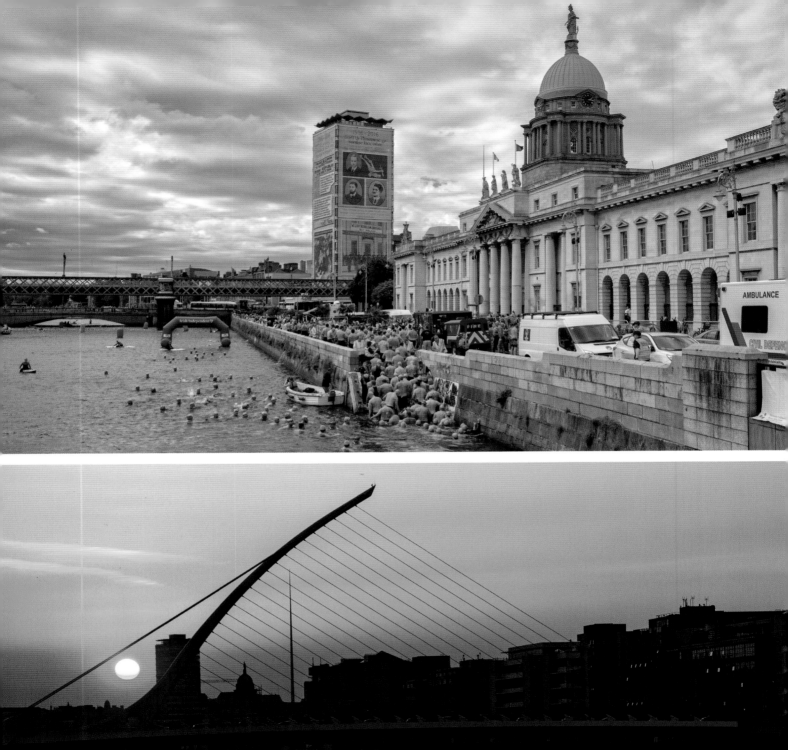
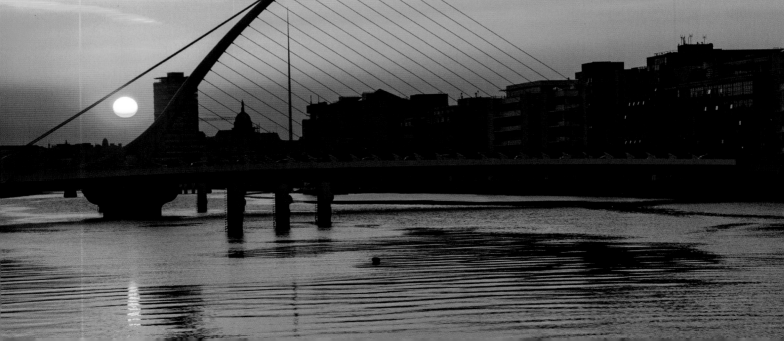

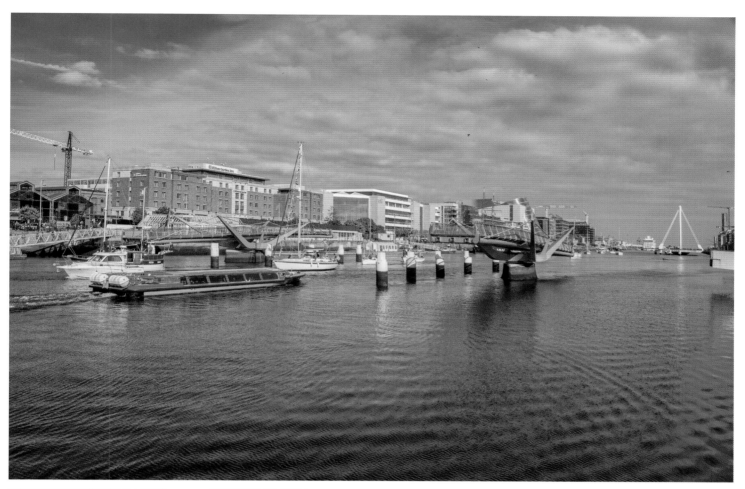

Left page, top: The Liffey Swim, currently titled the **Dublin City Liffey Swim**, is an annual race and is one of Dublin's most celebrated traditional sporting events. The first Liffey swim was in July 1920. One of the earliest Liffey swims was portrayed in the Jack B Yeats 1923 painting entitled *The Liffey Swim*, which is in the National Gallery of Ireland, in Dublin.

Left page, bottom: The Samuel Beckett Bridge, Liberty Hall, Custom House and the Millennium Spire, as the sun sets over the **River Liffey**.

Right page, top: 'Parade of Sail' up the River Liffey – as the Seán O'Casey Bridge and Samuel Beckett Bridge are opened to allow sailing boats and a water taxi through.

Right page, bottom: When the warm weather comes inner-city teenagers jump into the Liffey and canals from any vantage point, and any height.

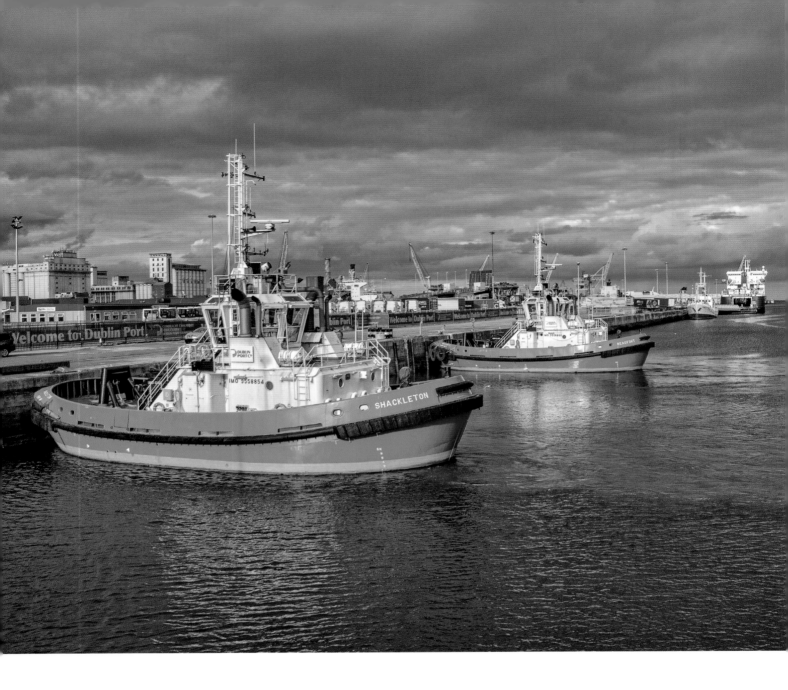

Above: The Dublin Port Company provides a number of key services, towage being one of them. The tug boats *Shackleton* and *Beaufort* were named after two Irish patrons of exploration: Ernest Shackleton, a fearless explorer, whose legacy lives on as an inspiration to all pioneers, and Sir Francis Beaufort, a tireless innovator who created a scale of measurement for wind force.

Right page, top: Tallships resting at the quayside, as viewed from the East–Link Bridge.

Right page, bottom: Sailing boats coming through the lifted East-link Bridge (official name: the **Thomas Clarke Bridge**, in honour of the republican executed for his part in the 1916 Easter Rising), with a soaring cruise liner and a traditional West of Ireland currach in the foreground.

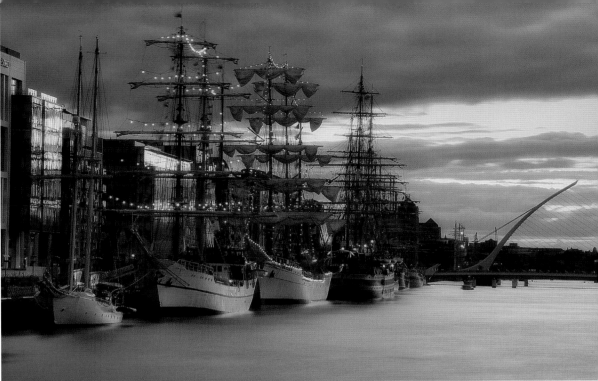

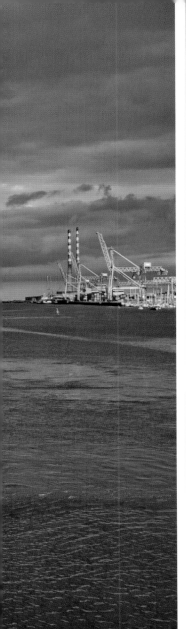

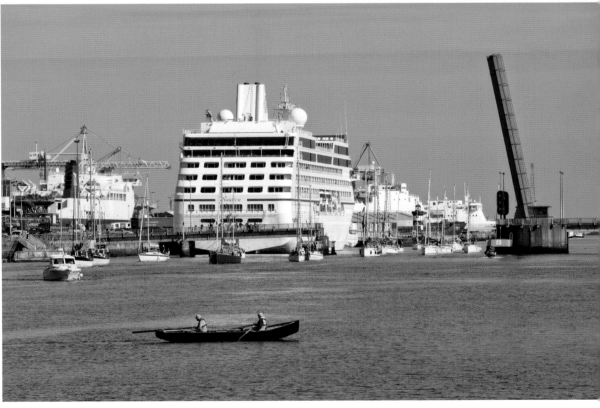

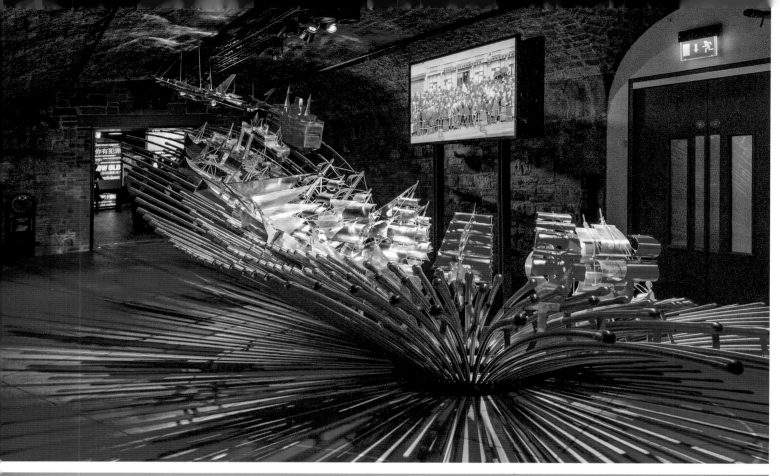
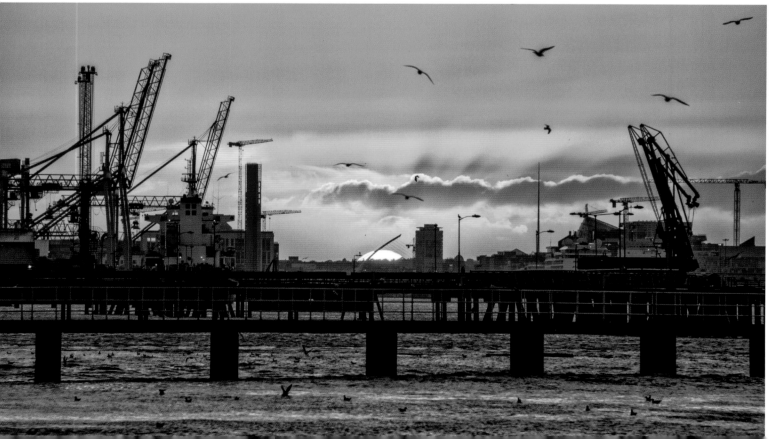

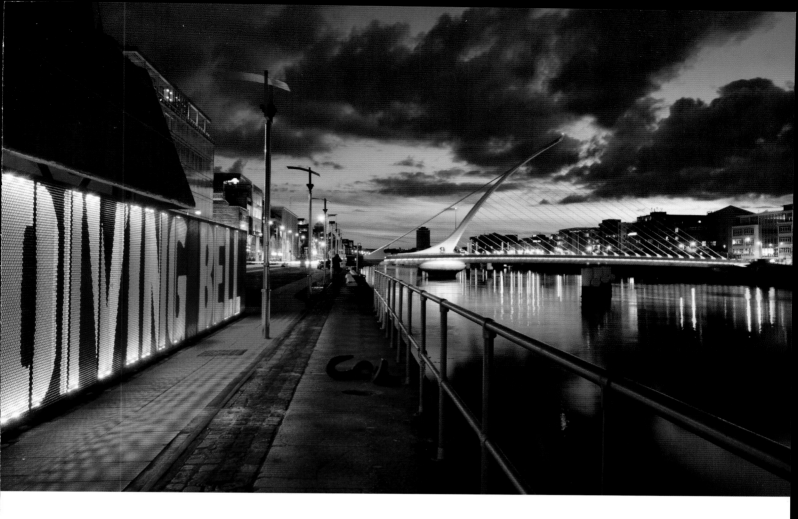

Above: Dublin Port's '**Diving Bell**' was used for almost 90 years to build the city's quay walls. The Diving Bell has been refurbished to offer an insight into how the city's port walls were constructed. Visitors can now walk through the structure's interior, with a water feature below, and a public exhibition explains the history of the artefact.

Left page, top: A stunning silver piece of art, one of the exhibits inside **EPIC, The Irish Emigration Museum**, depicting all the various modes of transport Irish people have used to leave the country, from coffin ships to huge modern long-haul jet aircraft. Epic Ireland tells the story of Irish people all around the world, using digital technology to deliver incredible visual stories with a high level of interactivity.

Left page, bottom: Looking upriver from **Poolbeg** as the camera captures the dying glow of the sun. Nearby, just a few kilometres from the city centre, in Ringsend, Dublin has its own yacht club, Poolbeg Yacht & Boat Club, with a modern 100-berth marina. The area has a colourful maritime tradition, stretching back to the 17th century.

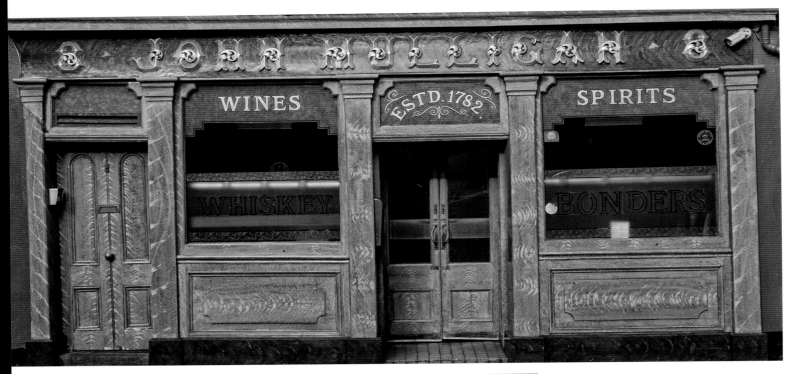

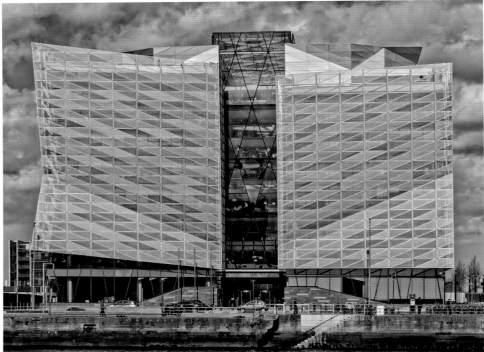

Top: Mulligan's, on **Poolbeg Street**, is more than a Dublin pub; it is an Irish cultural phenomenon, known for the quality of its Guinness. It has a unique and colourful history, spanning over two hundred years. Mulligan's has hosted the famous, including Judy Garland, Seamus Heaney, Con Houlihan, James Joyce and John F Kennedy.

Bottom: The Central Bank of Ireland Headquarters, North Wall Quay.

Right page: A long exposure renders a certain beauty to the **North Bank Tower Lighthouse**, a key navigational aid in the bay.

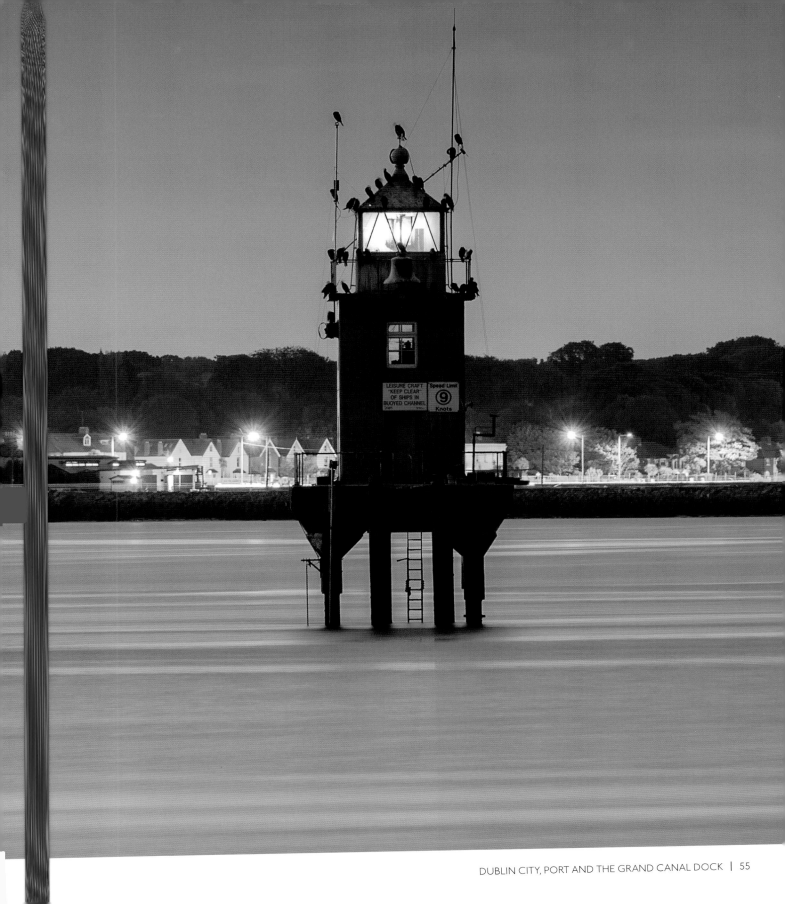

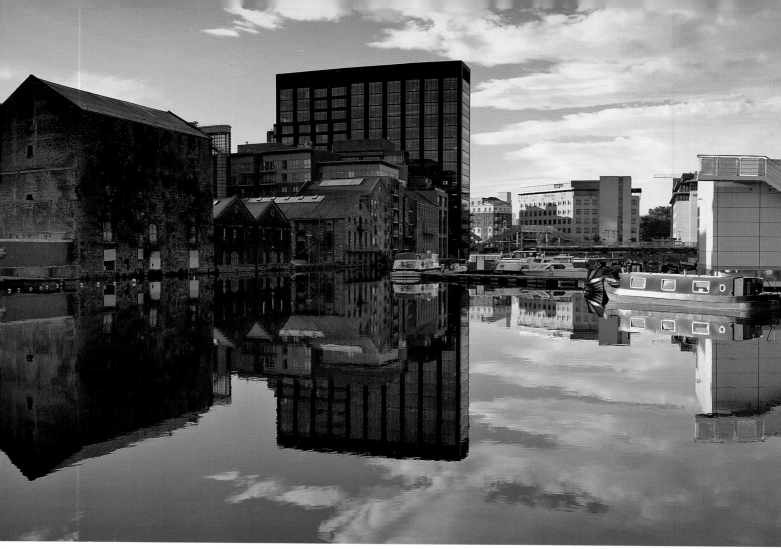

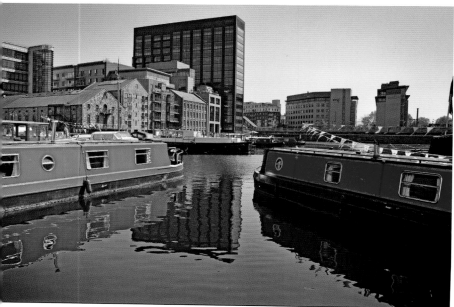

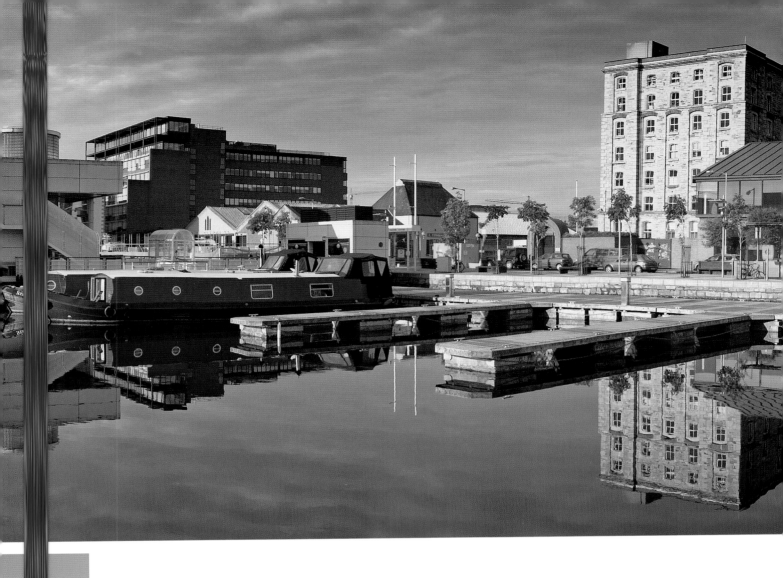

GRAND CANAL DOCK

Left page, top and bottom left: The **Grand Canal Dock** opened its two rectangular basins in 1796. The docks fell out of use and became derelict. Regeneration in the late-1990s, led to the arrival of new residents and the establishment of the Silicon Docks, home to high-tech multinationals, such as Google, Facebook, Twitter, Linkedin and Airbnb.

Left page, bottom right: A view of the **Millennium Square**, designed by landscape architect Martha Schwartz, which fronts the Bord Gáis Energy Theatre. A red 'carpet' of resin-glass paving extends from the theatre out over the dock and is dotted with red, glowing angled light sticks.

Above: Eye-catching and light-catching modern shapes bring vitality and regeneration to **Grand Canal Dock**.

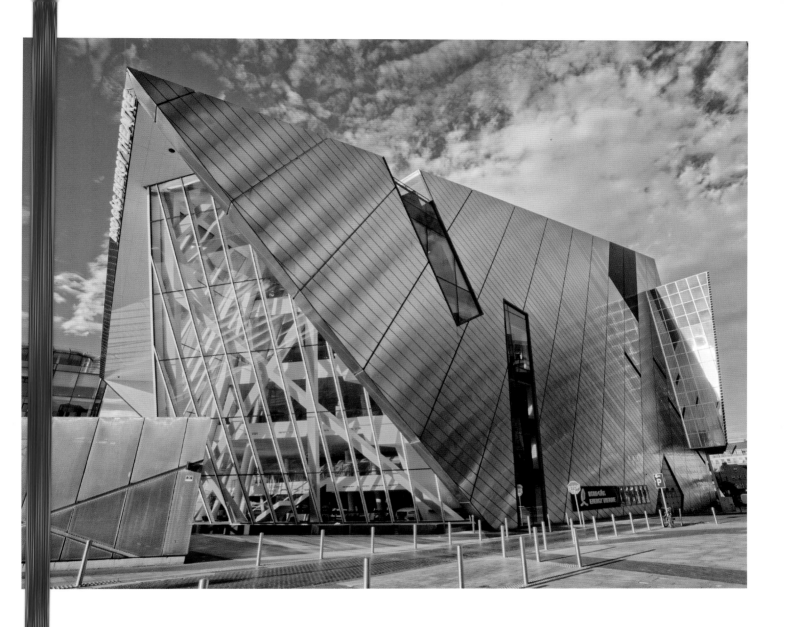

ve: The **Bord Gáis Energy Theatre**
e largest theatre in Ireland, with a
-capacity. The striking, glass-fronted,
ular structure was designed by Polish-
erican architect Daniel Libeskind.

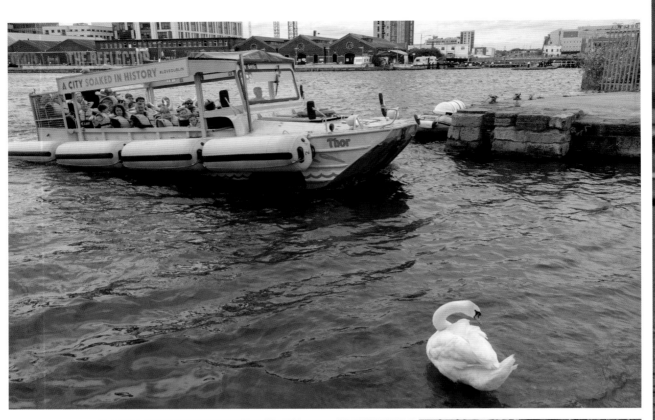

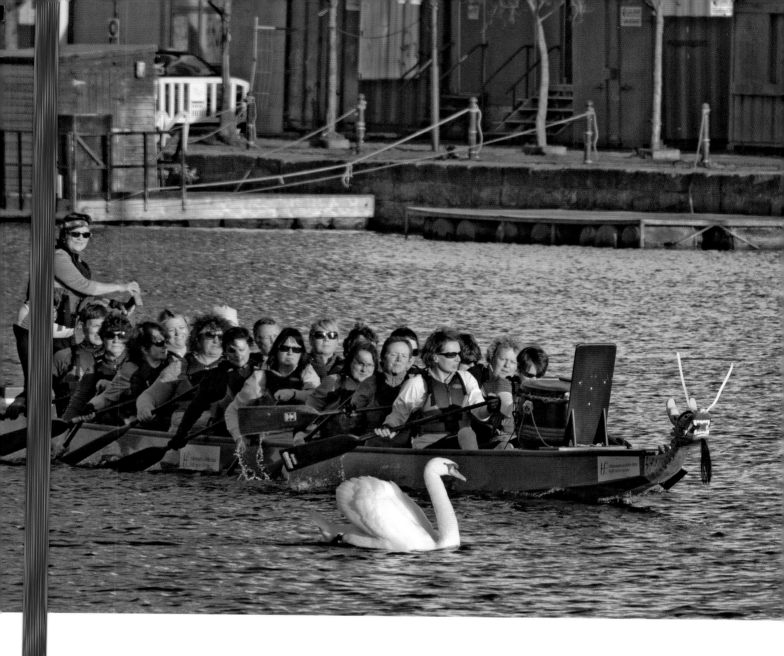

Above: Swan meets 'Dragon' on the waters of the
Grand Canal Dock, a popular spot for all sorts of
water based activity.

Left page, top: A popular visitors' attraction – the
Viking Splash Tour – is seen here leaving the canal
dock.

Left page, bottom: Wakeboarding in the dock.

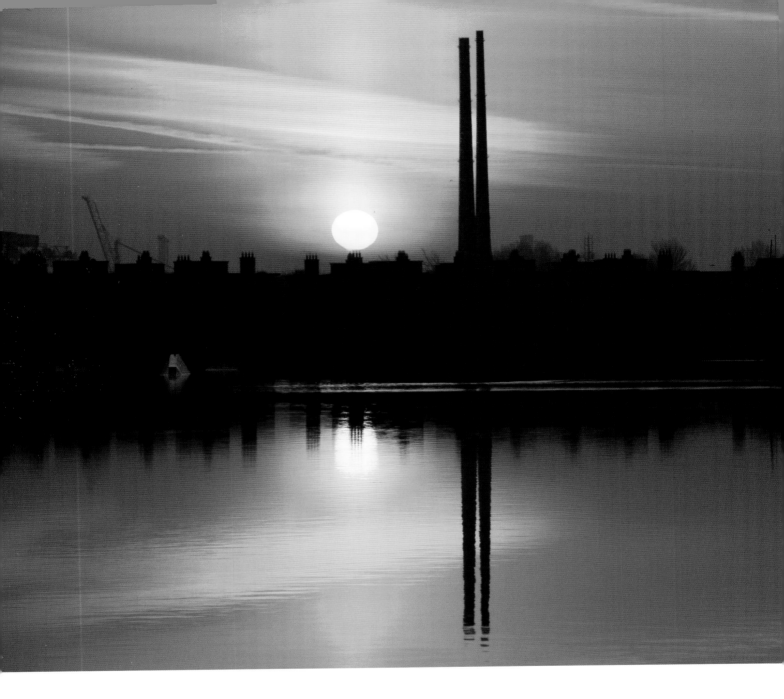

Above: The famous **Poolbeg Chimneys** are silhouetted by the March sunrise over the Grand Canal Dock.

Right page: A steam train puffs past **Grand Canal Dock Dart Station**, providing, with the barges on the water, a neat composition, echoing two modes of transport from the 1800s when the Grand Canal docks were working docks.

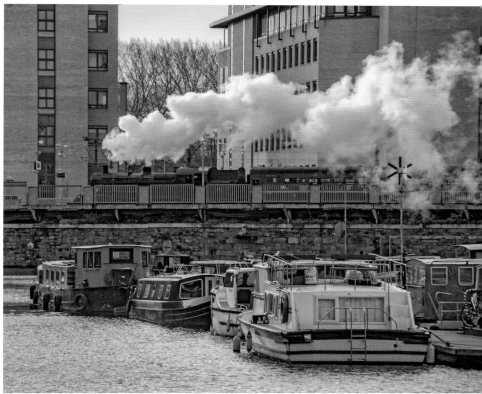

Am I walking into eternity along Sandymount Strand?

James Joyce, *Ulysses*

SANDYMOUNT AND THE GREAT SOUTH WALL

The village of Sandymount, 3 kilometres to the south-east of Dublin city, was established as an exclusive residential area, on lands belonging to the Earl of Pembroke in the early 19th century. The development of the Kingstown Railway in 1834 made the area accessible for commuters and day-trippers alike. Sandymount Strand is arguably one of the most famous beaches in Irish literature providing the backdrop for a number of scenes in James Joyce's *Ulysses*.

Joyce is not the only world-renowned literary figure with ties to this small village. WB Yeats was born in Sandymount in 1836, and Seamus Heaney made Sandymount his home. Busts in honour of both men can be found in Sandymount Green, the small, triangular park at the heart of this vibrant village.

Sandymount and surrounding areas host an abundance of wildlife. The lowland marshes provide a perfect habitat for migrating birds. From Sandymount Strand, one can take a stunning walk through Irishtown Nature Park, past Poolbeg and on to the Great South Wall of Dublin's port, which juts out from the mouth of the Liffey. From here, it is easy to forget that you are mere kilometres from the hustle and bustle of Dublin city.

'The Angel of the Sea' monument marks the start of the Sandymount promenade at the southern end. A disused Martello Tower remains intact at the halfway point, looking out over the remnants of Sandymount Baths. The seawater swimming baths, built in 1883, were popular with Dubliners in the mid-late 19th century but fell into disrepair in the early 20th century. From one of the benches dotted along the promenade one can enjoy the sweeping vista of Dublin Bay, all the way from Howth Head to Dún Laoghaire.

However, most striking in this vista are the iconic red and white striped Poolbeg Chimneys that dominate the Dublin skyline. When construction started on the chimneys as part of the expansion of the power station in Poolbeg in 1969 they were considered an eyesore. Over time, they have found a place in many Dubliners' hearts, and they obtained protected structure status in 2014.

This area of Dublin Bay is also a mecca for sports fans. The nearby, recently redeveloped Aviva Stadium at Lansdowne Road is home to both Irish rugby and soccer.

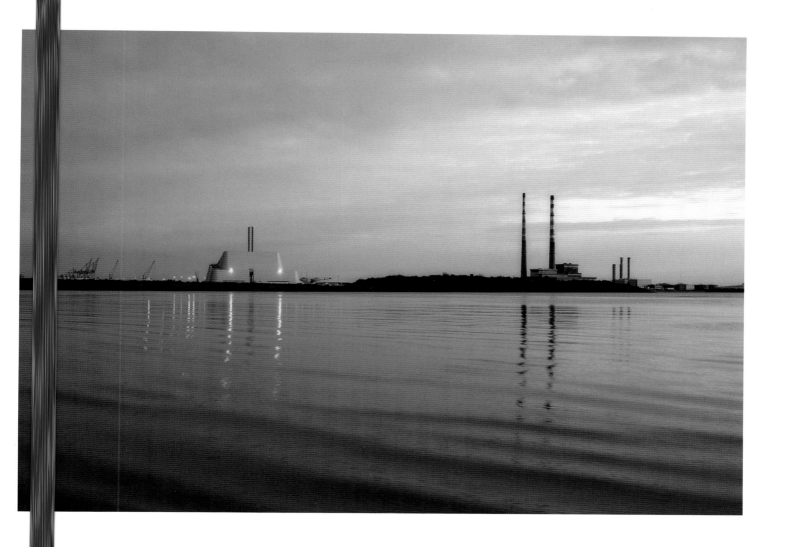

SANDYMOUNT

Just before sunrise. **Sandymount Strand**, or *Dumhach Thrá*, is 4 kilometres from the centre of the city and is popular with walkers and runners. There is a Martello tower midway along the strand. This strand features Leopold Bloom spying on young Gerty as she lifts her skirt in James Joyce's *Ulysses*, making it one of the most famous beaches in Irish fiction. As a shallow tidal mudflat, it attracts thousands of birds and is perfect for bird watching.

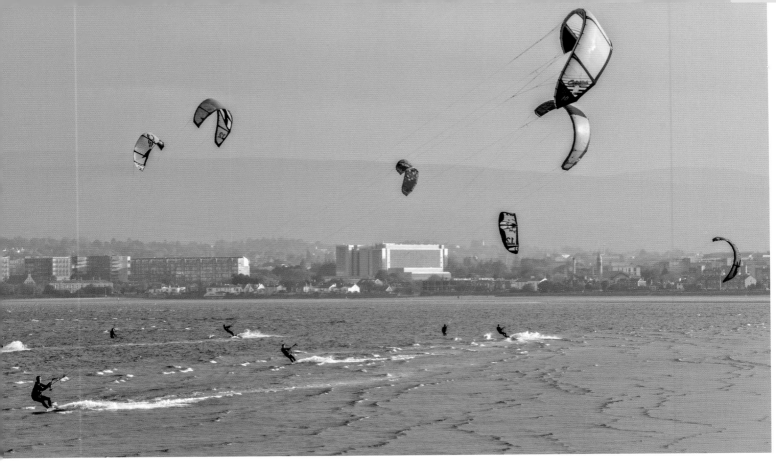

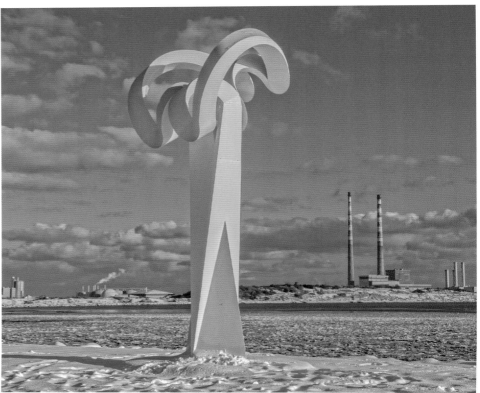

Top: The skies above **Sandymount Strand** and waters swirl with the kites of surfers.

Bottom: *Awaiting the Mariner* – also named *An Cailín Bán* (and known in English as *The White Lady*), Sandymount Strand, a sculpture by Mexican artist Sebastián.

Right page: Dog heaven. Low tide on Sandymount Strand. The disused **Poolbeg Chimneys** of the old electricity generation station are beloved by Dubliners, signifying home, as the traveller approaches Ireland's eastern shore. The Poolbeg Station was built in 1965 beside the old Pigeon House Generating Station, which began service in 1903, and which was an 18th-century hotel owned by a Mr Pigeon. The 21st century has seen the arrival of a new waste-to-energy incinerator plant on the familiar skyline.

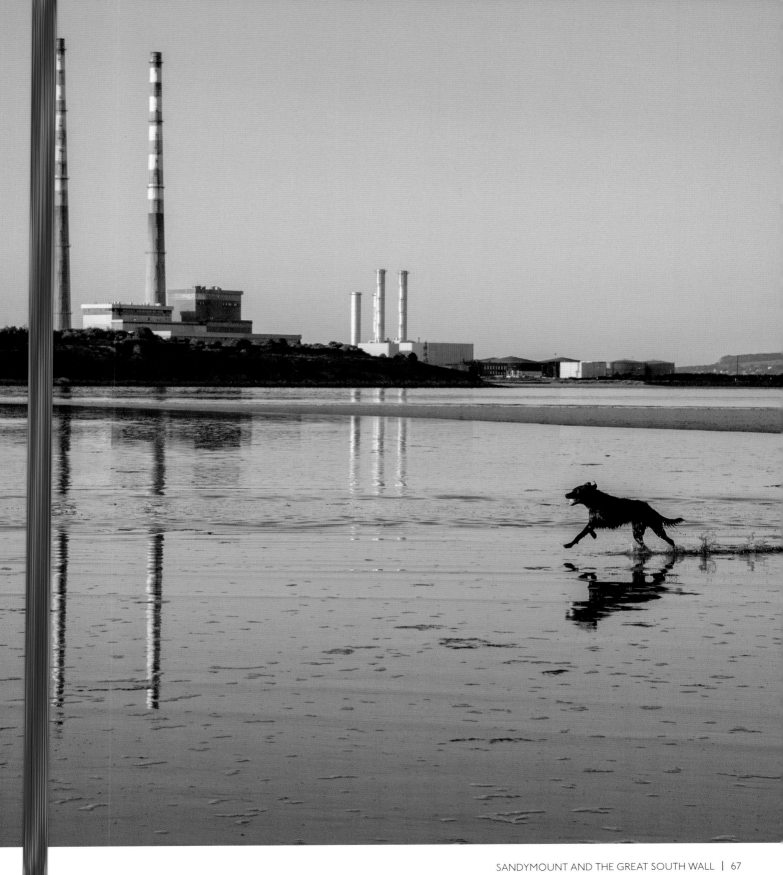

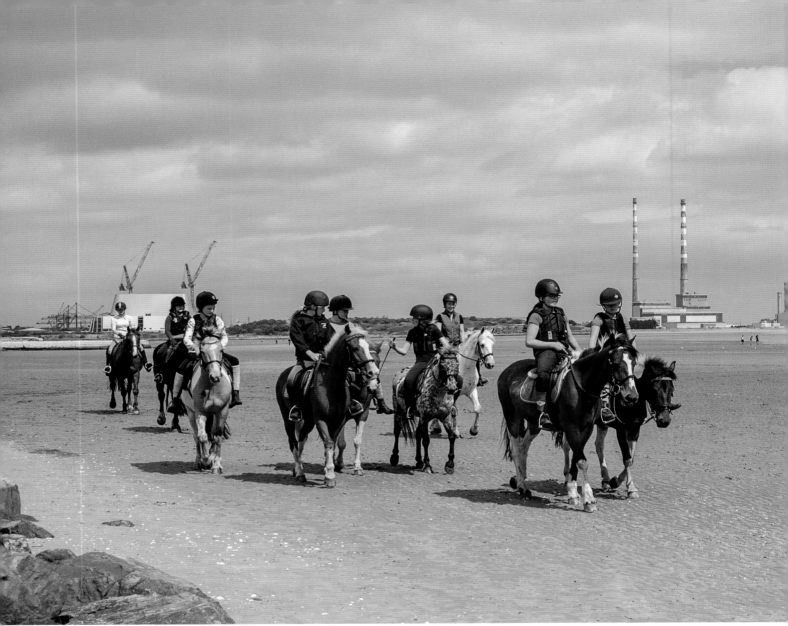

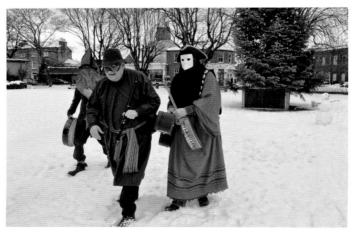

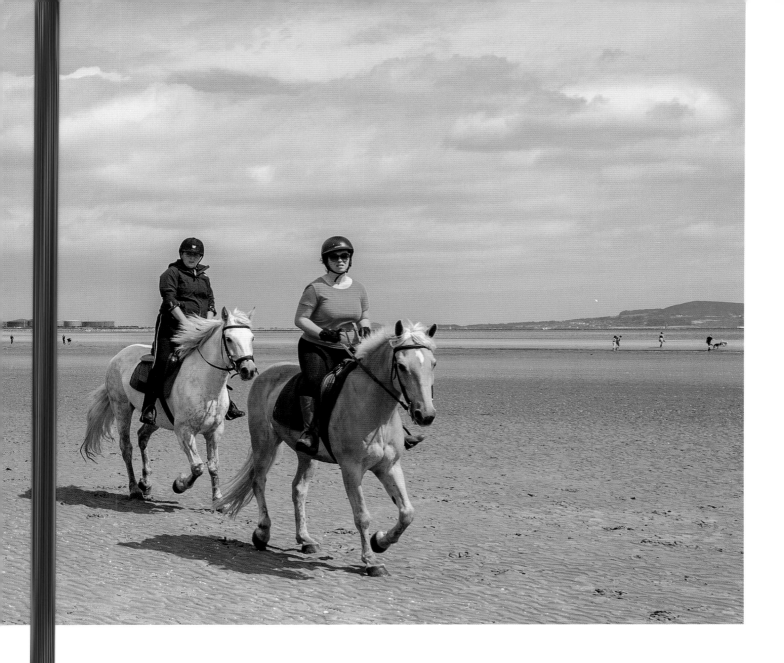

Above: Horse riding when the tide is out on **Sandymount Strand**.

Left page, bottom left: Early morning exercise, **Sandymount Strand**.

Left page, bottom right: Traditionally in Ireland the wren is a symbol of the old year, and the robin signals the year to come. On St Stephen's Day, 26 December, local boys used to hunt and kill a wren. The '**Wren Boys**' wore costumes and masks and would go from house to house, carrying the wren in a box. They sang laments for the unfortunate bird in return for money for the funeral.

"

The wren, the wren, the king of all birds,
On St Stephen's Day was caught in the furze;
Up with the kettle and down with the pan,
Pray give us a penny to bury the wran.

Traditional Irish Wren song

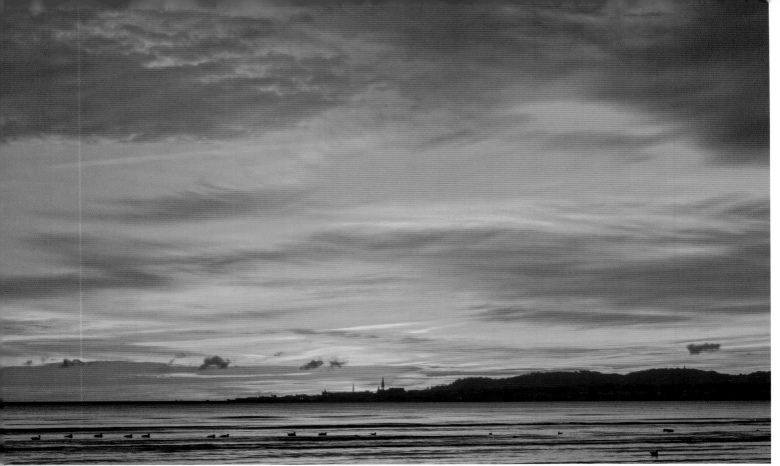

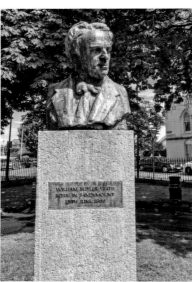

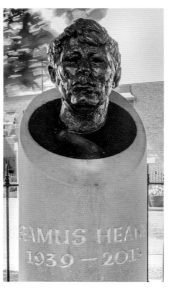

Dance there upon the shore;
What need have you to care
For wind or water's roar?
And tumble out your hair
That the salt drops have wet
WB Yeats,
from 'To A Child Dancing in the Wind'

Top: The southern sky is aflame, just before sunrise, as Dún Laoghaire is viewed from Sandymount Strand.

Bottom: Taking pride of place on Sandymount Green, two busts of Nobel Prize winners in Literature that lived for a time in Sandymount: WB Yeats and Seamus Heaney.

Right page: St John the Evangelist's is an unusual church in that it has no parish. Since its foundation, in 1850, it has been known for Anglo-Catholic worship (an Anglican faith that emphasises its Catholic heritage). It is a replica of a 13th-century church in Normandy, which makes it the only example of Neo-Norman architecture in Dublin.

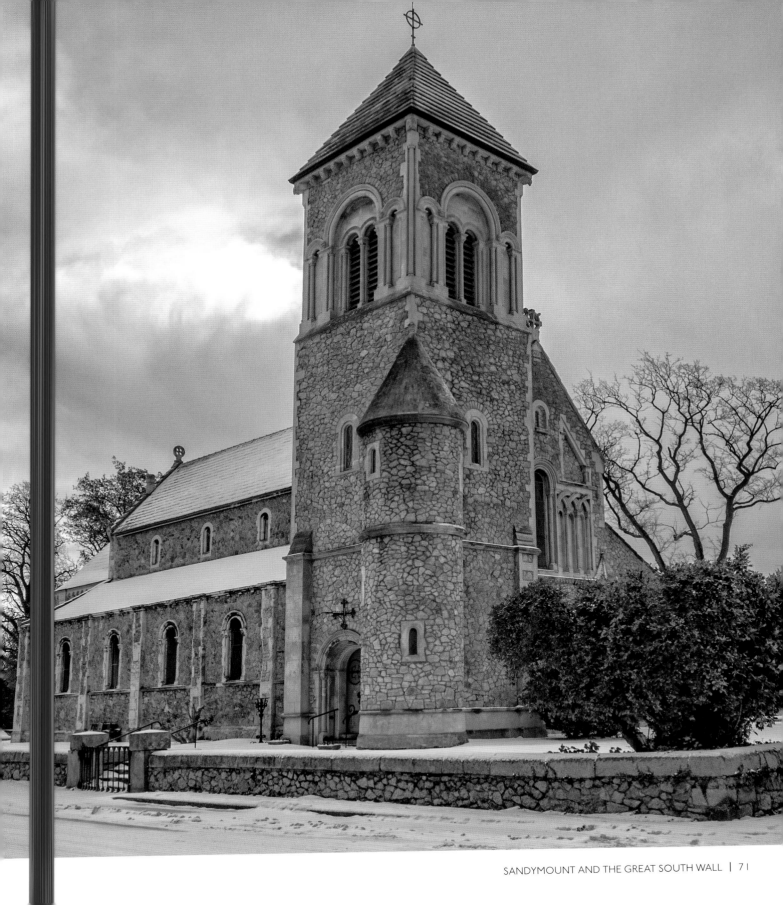

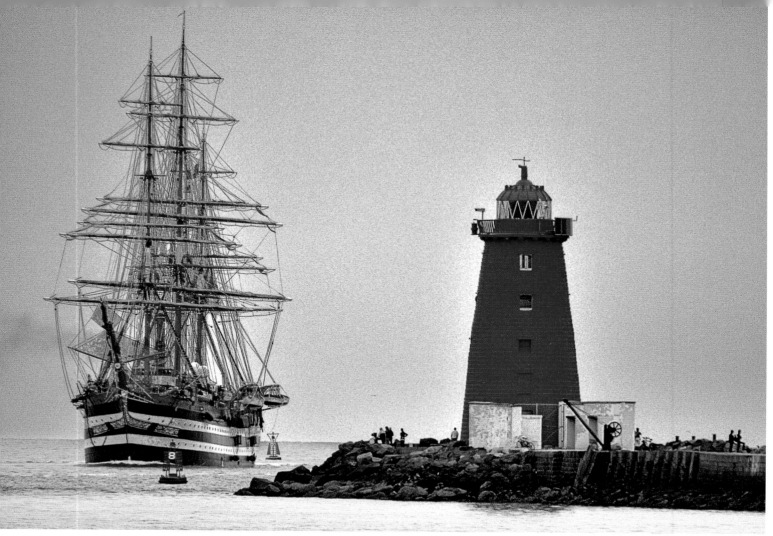

THE GREAT SOUTH WALL

Top: The Italian navy-school tallship *The Amerigo Vespucci* passing **Poolbeg Lighthouse**, at the entrance to Dublin Port, on a visit to Dublin.

Bottom: **The Great South Wall** (also known as The South Bull Wall) at the mouth of Dublin Port extends from Ringsend out into Dublin Bay. It remains one of the longest sea walls in Europe. This 4-kilometre walk (there and back) is a favourite with Dubliners, taking the walker away from the busy city out to the Poolbeg Lighthouse at its end.

Right page, top: The cruise ship *Ocean Princess* meets the Stenaline ferry at the **Poolbeg Lighthouse**.

Right page, bottom: As one heads upstream all navigational aides are red on the port side and green on the starboard, as with the **North Bull Lighthouse**.

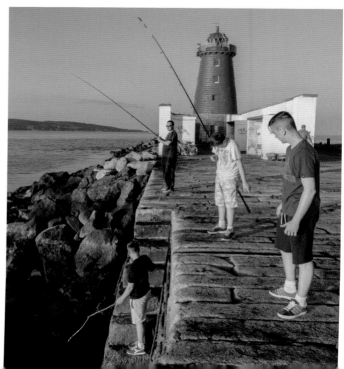

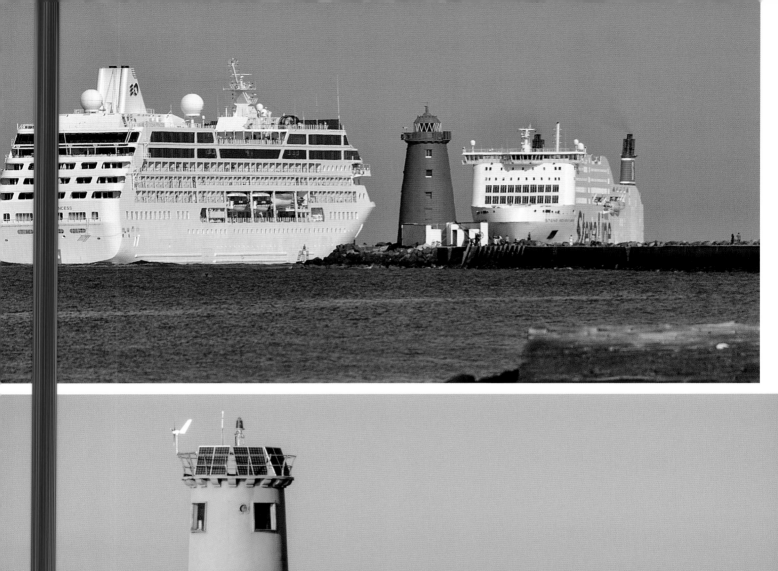

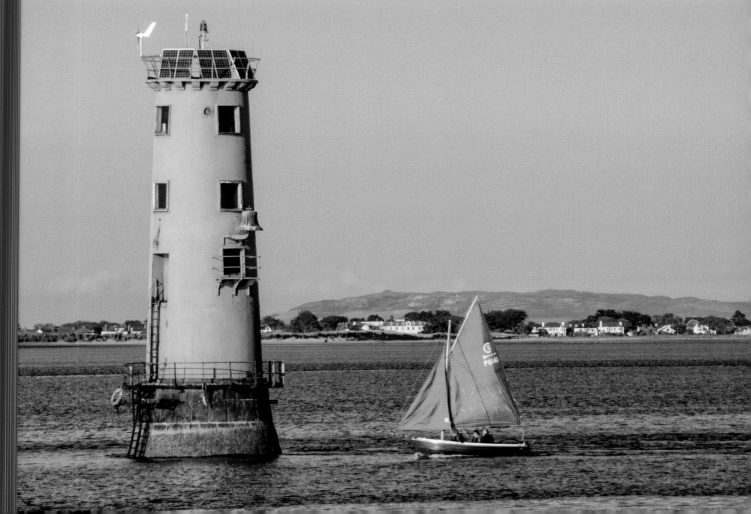

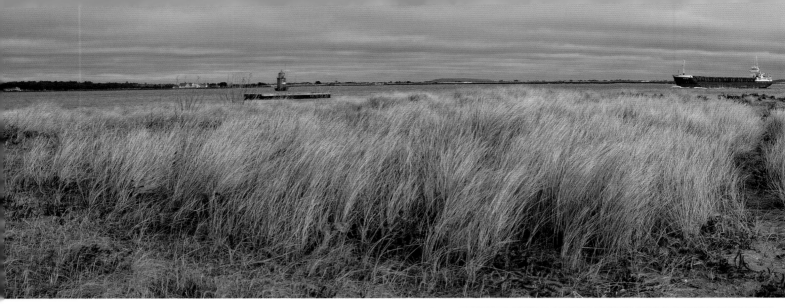

Top: The small wild beach at the start of the **South Wall walk**, with the dark shape of Howth Head on the horizon and the old fort on the Wall. With the threat of French invasion after the 1798 Rebellion, the Pigeon House Fort was built, housing soldiers, a hospital, a handball alley and an armoury.

Bottom: At low tide on the Poolbeg side of **Sandymount Strand**, the wind gives a kite-surfer great lift and causes the sand to move at speed. An old wreck of a boat protrudes from the sand, proof that the surrounding waters can be dangerous.

Right page, bottom: The red **Poolbeg Lighthouse** and the 207-metre-high **Poolbeg Chimneys** are well-known landmarks. The fate of the redundant chimneys is undecided, although they are protected structures. The Chimneys feature in the short story 'An Encounter' in James Joyce's *Dubliners*.

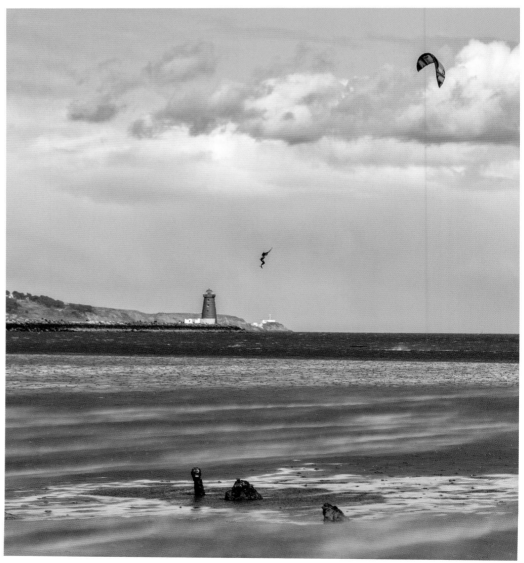

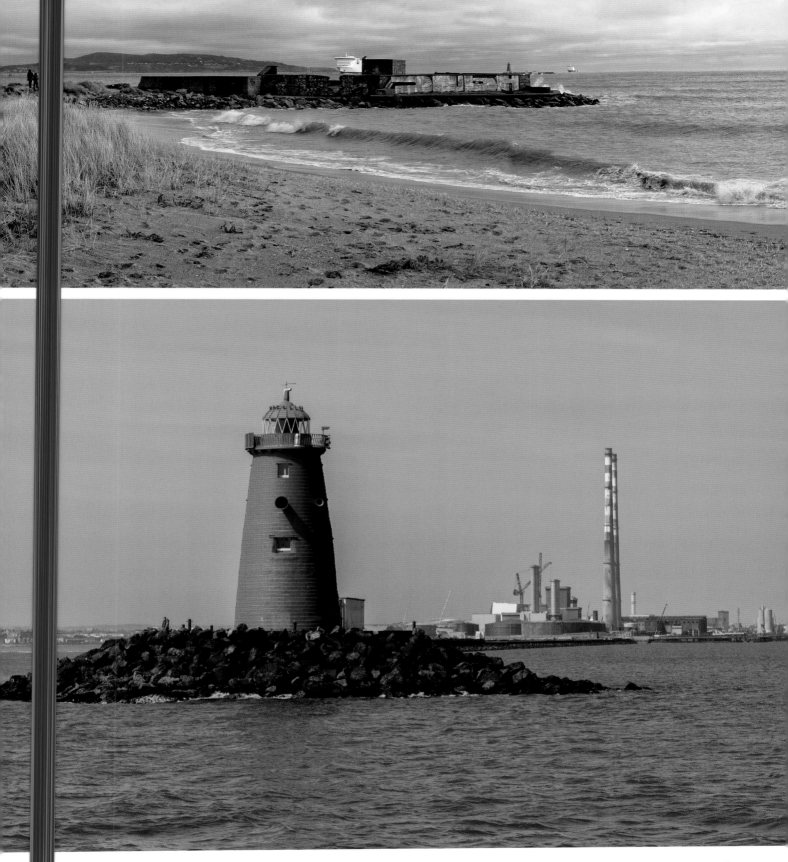

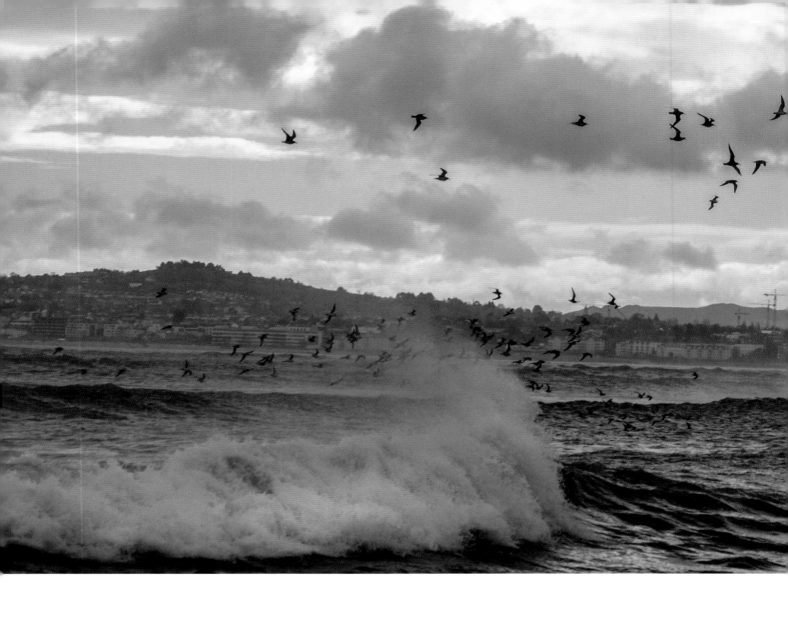

A stormy day at the **South Wall** as waves break over the
Poolbeg Lighthouse (far right) and birds wheel as the breakers
roll in, with the Sugar Loaf mountain grey against the horizon.
The sands take on a surreal quality, rushing in the strong winds.

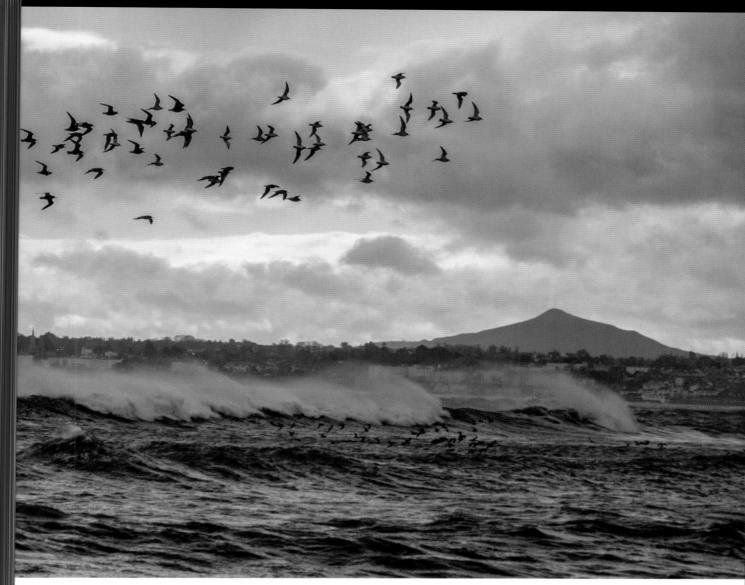

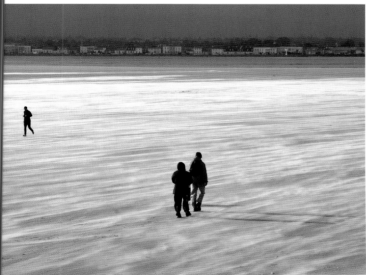

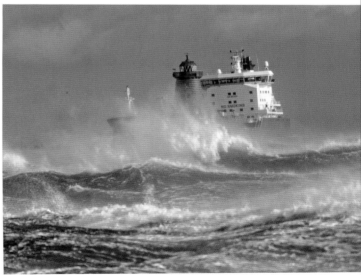

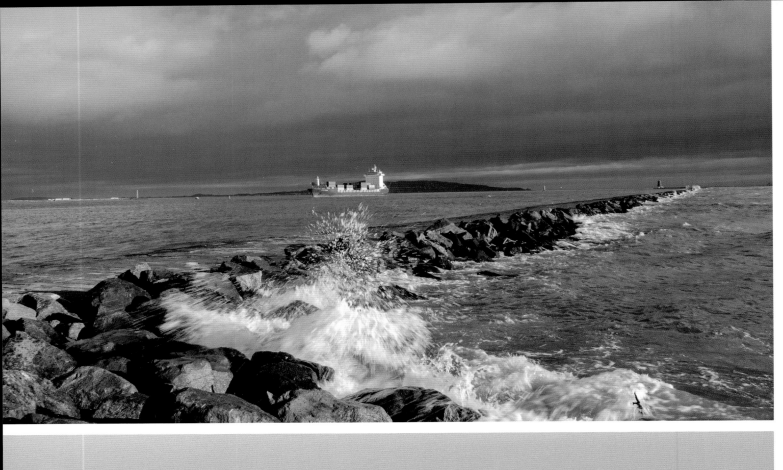

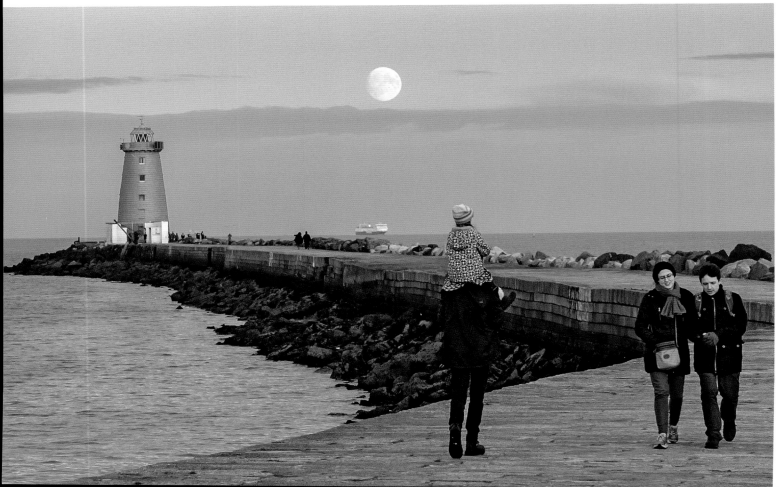

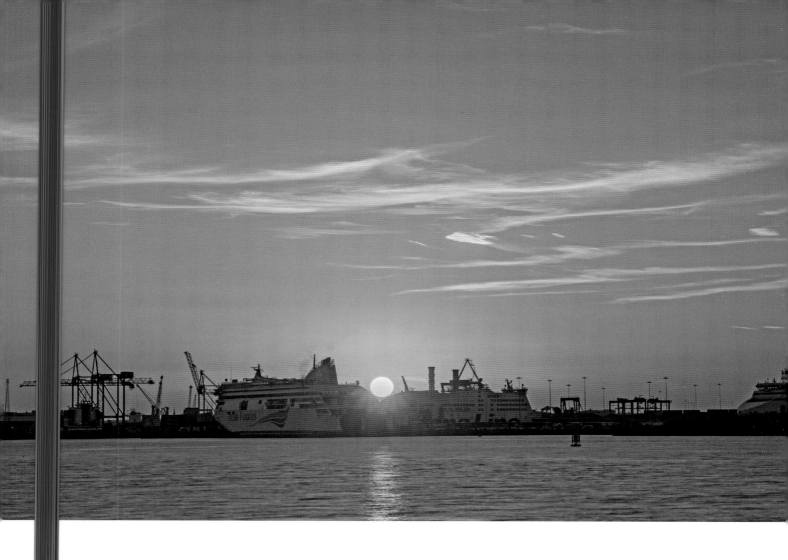

Ab[ove]: The setting sun embues the **Dublin Port** skyline with its own lum[ino]us beauty, as viewed from the South Wall.

Le[ft pa]ge, top: Just before rain. A container ship entering **Dublin Port** is s[i]l[houetted] against glowering skies. The ever-changing light and weather of Du[blin] Bay generate magic moments in photography.

Le[ft pa]ge, bottom: A **Supermoon** seen rising over the South Wall of Du[blin] Port.

FROM BOOTERSTOWN TO SALTHILL

*S*lighe Chualann was an ancient Irish road that followed the course of what is now known as the Rock Road, running from Booterstown through Blackrock and on southwards towards Bray in County Wicklow. The ancient road once linked the seat of the High King of Ireland in Tara, County Meath, with south east Dublin and north Wicklow.

The construction of the Kingstown Railway in the 1830s led to the formation of marshland along this stretch of the coastline. The saltmarsh at Booterstown is the only one of its kind in south Dublin and has been designated a nature reserve due to its importance for birdlife.

Further along the coast, a section of the marshland was reclaimed in the 1870s to build Blackrock Park. The park, with its large pond and traditional bandstand, stretches from Booterstown to Blackrock Village. Blackrock is a bustling village with two shopping centres and the main street is dotted with interesting shops, restaurants and bars. At weekends, one can rummage away at the longstanding Blackrock Market.

The beach at Seapoint has long been a favoured swimming spot for those brave enough to take a dip in the Irish Sea. The Martello Tower at Seapoint was formerly the headquarters of the Geneological Society of Ireland, which has since moved to Dún Laoghaire.

Taking the coast road south, one cannot help but notice the magnificent Victorian terraces which look out over the sea at Salthill and Monkstown. The development of the harbour at Dún Laoghaire and, later, the opening of the railway made this area popular with wealthy Dubliners looking to escape the hustle and bustle of the city. That relaxed village atmosphere remains today and Monkstown boasts a number of boutique shops and restaurants that draw visitors from neighbouring suburbs.

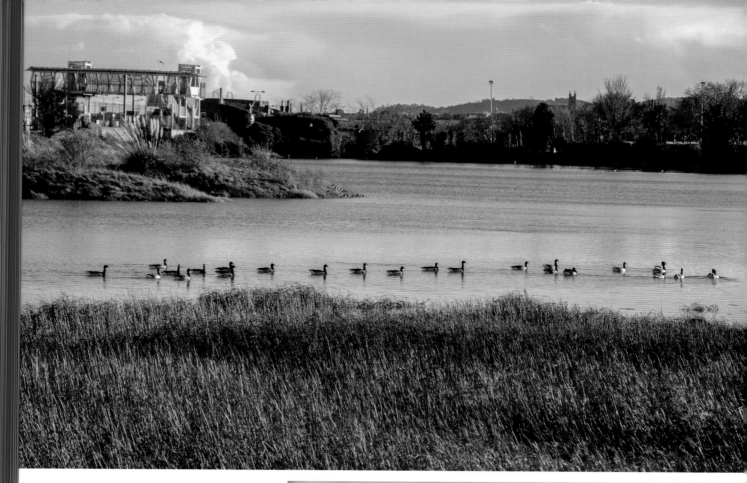

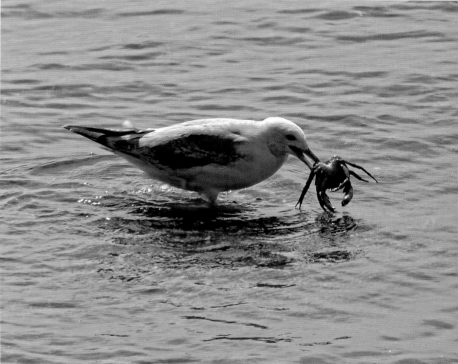

Top: **Booterstown Marsh** is a brackish marsh nature reserve and bird sanctuary between the railway line and the Rock Road. The marsh is important for wading birds such as the common snipe and curlew. Herons, ducks and redshanks are also to be seen, and, if you are lucky, the thrilling flash of turquoise iridescence of a kingfisher by the Williamstown Stream that flows parallel to the sea wall just south of the marsh.

Bottom: Lucky catch – a **common gull** has a successful fishing outing.

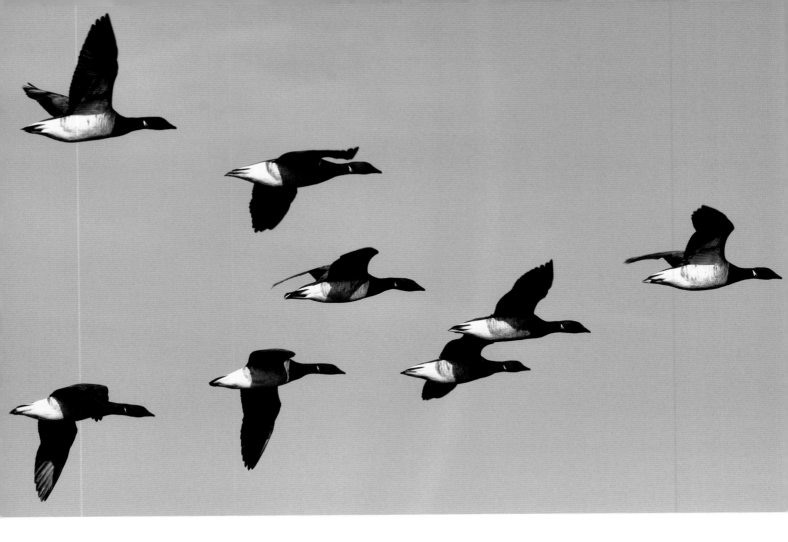

Above: **Brent geese** arriving at Booterstown.

Right page, top: With their long bills, **waders**, such as these black-tailed godwits, are wonderfully adapted to feed in the shallows at Booterstown.

Right page, bottom: A **shag** has a moment's rest.

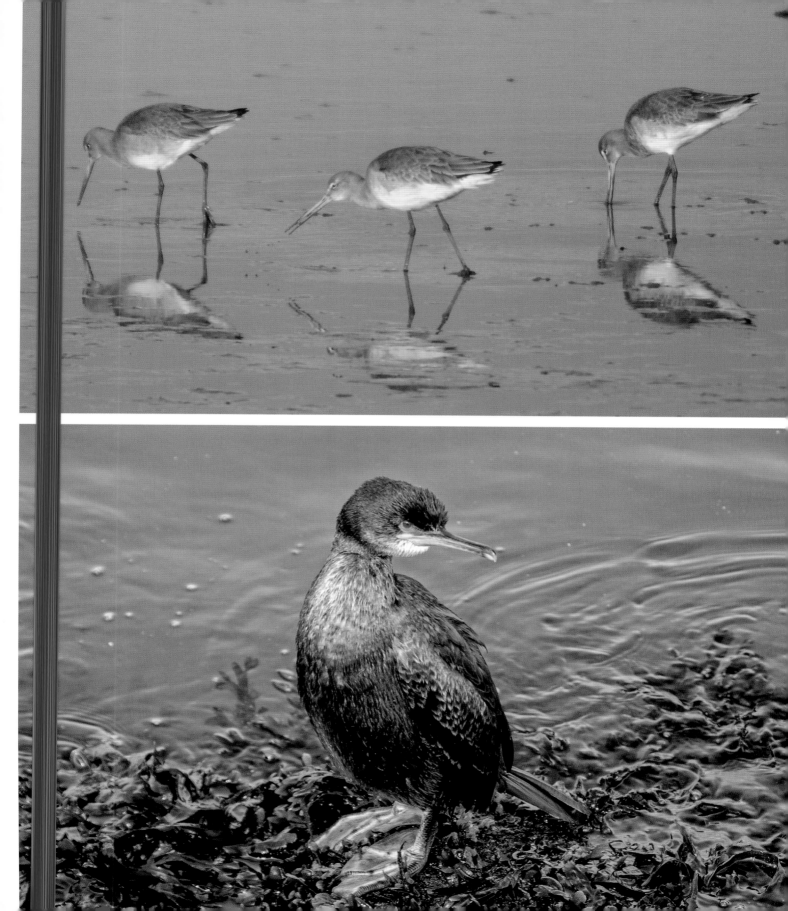

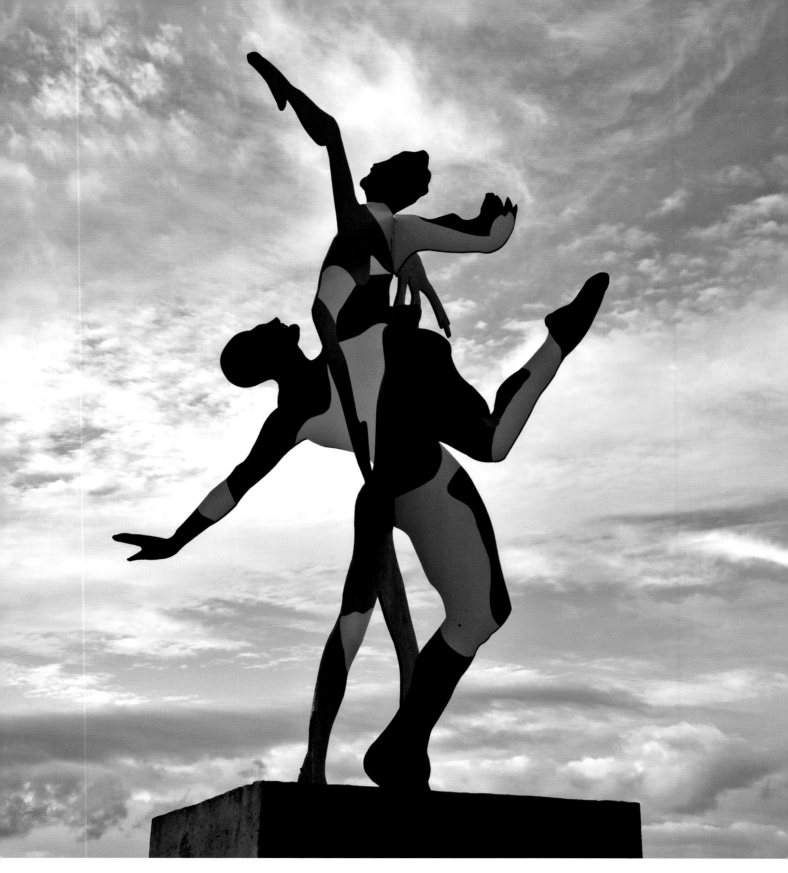

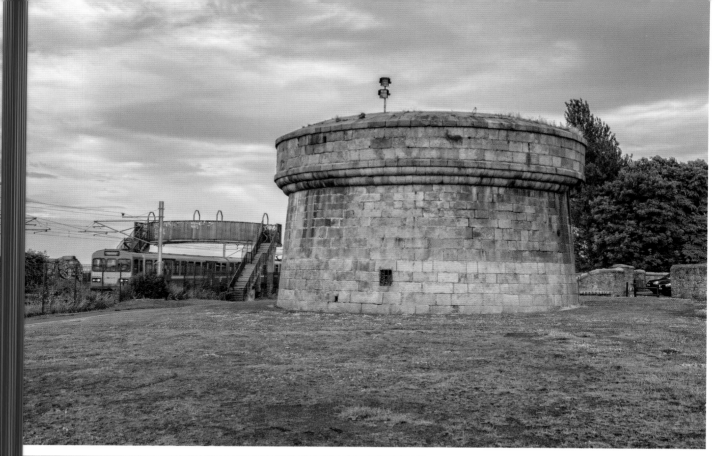

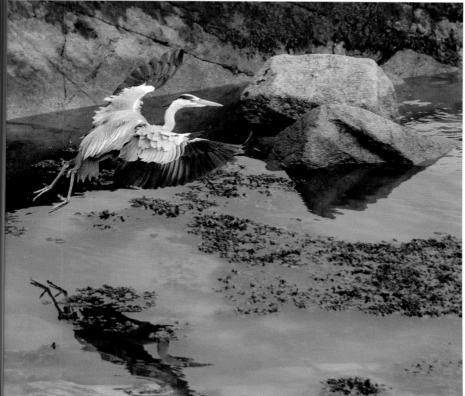

Top: The **Martello tower** in Blackrock Park, at Williamstown, was built 1804–06, and is one of sixteen that originally dotted the coast (some have since disappeared) between Sandymount in Dublin and Bray in County Wicklow. These coastal fortifications were constructed during the Napoleonic era, when fears of a French invasion ran high.

Bottom: Heron coming in to land.

Left page: *Cut Out People* by sculptor Dan McCarthy in **Blackrock Park**. Intertwining, two-dimensional human figures flow and dance together in a sculpture full of movement and joy.

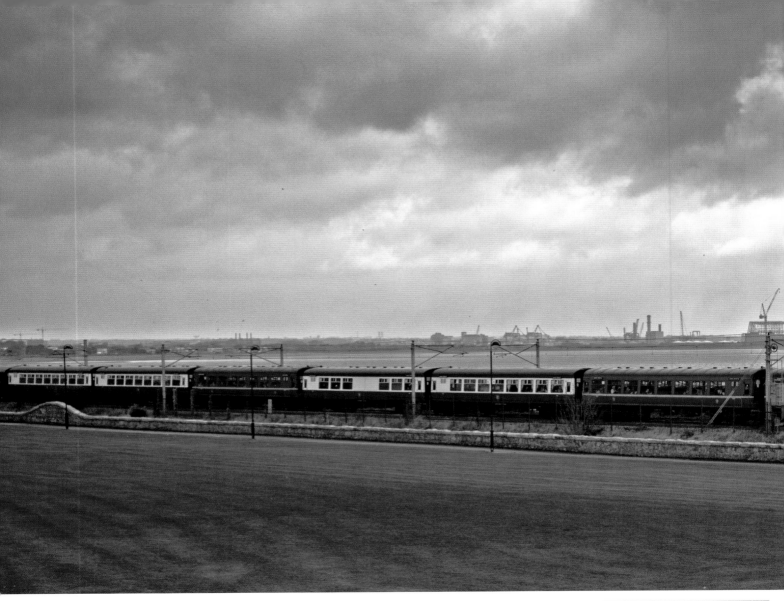

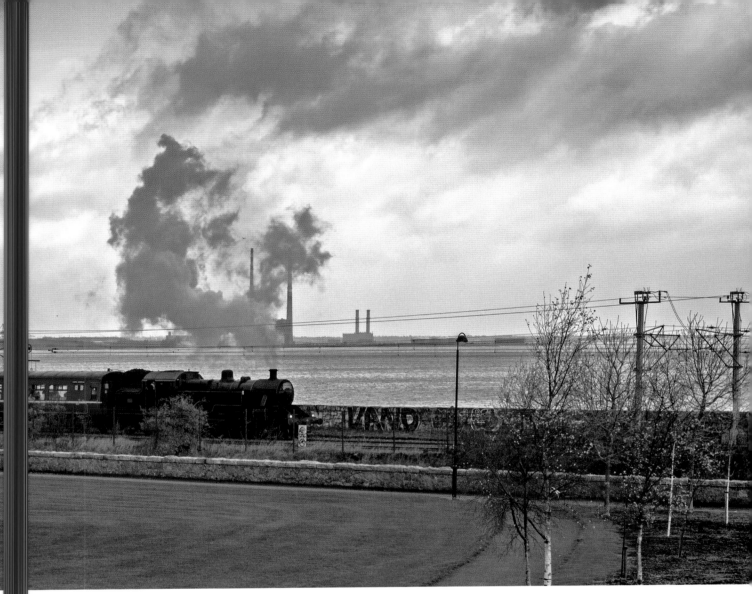

Top: A steam train running along Dublin Bay at **Blackrock Park**. The first railway was built in 1834, and ran between Westland Row in Dublin and Kingstown (Dún Laoghaire).

Bottom: A **robin** lends a flash of colour to spring in Blackrock Park.

Left page: **The Gardens of Remembrance** in Blackrock Park feature a granite copy of the 1916 Proclamation of the Republic, flagpole and seven trees to represent the seven signatories of the proclamation.

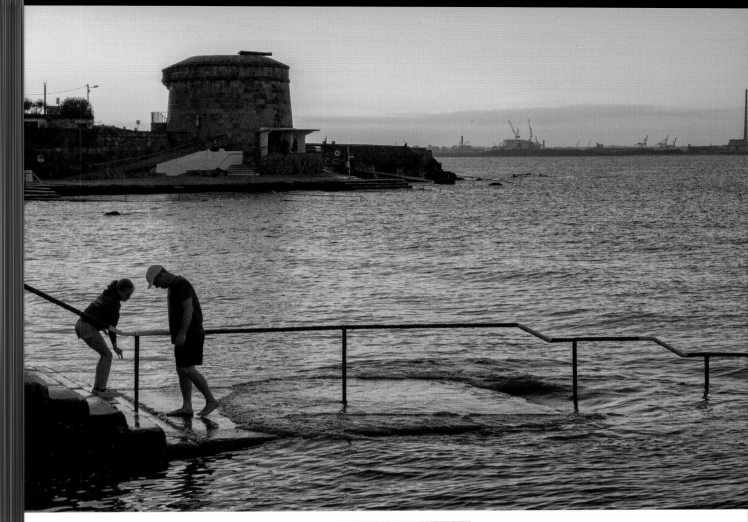

Top: Testing the water at **Seapoint**.

Bottom: Idrone Terrace, Blackrock, is a fine row of period houses with uninterrupted sea views, built in the 1840s.

Left page: Blackrock Market was established in 1996, and offers an array of fine art, modern art, collectibles, furniture, soft furnishings, hand crafts and food.

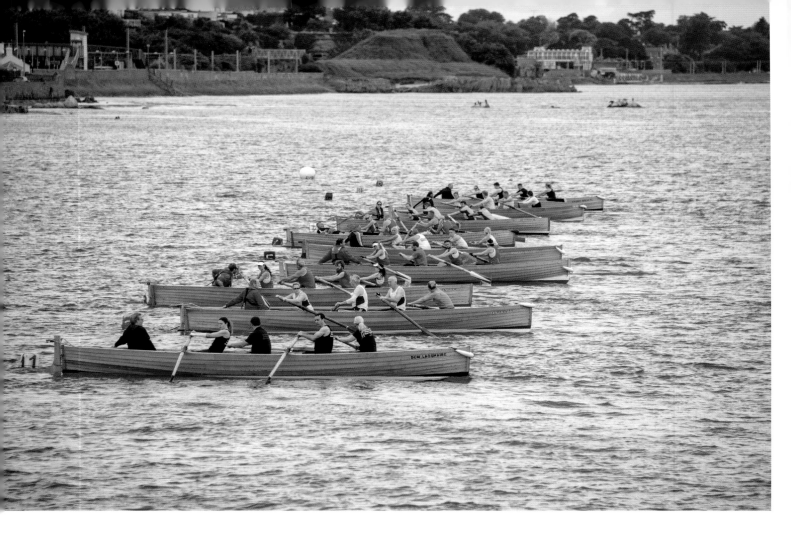

Above: The start of the race of **St Michael's Regatta,** during the Battle of the Bay. Almost every weekend during the summer months rowing regattas are held somewhere around the bay. They are organised by the East Coast Rowing Association and use 25-foot, wooden, clinker-built boats.

Right page, top: Walkers at low tide.

Right page, bottom: It is hard to imagine that on 19 November 1807 a terrible tragedy befell two ships in Dublin Bay, the brig *Rochdale* and HMS packet ship *Prince of Wales*, as both were beset by gale-force winds and heavy snow and wrecked on rocks between Dún Laoghaire and Blackrock, resulting in a huge loss of life. In the 19th century Dublin Bay was treacherous for sailing vessels. Dublin Port could only be entered at high tide, leaving ships stranded in all weathers. The bay was prone to sudden storms, rough waves, and the coastline was strewn with jagged rocks. Wrecks of over 600 ships lie at the bottom of the bay. As a result of these shipwrecks, and in particular those of the *Rochdale* and the *Prince of Wales*, Dún Laoghaire harbour came into being.

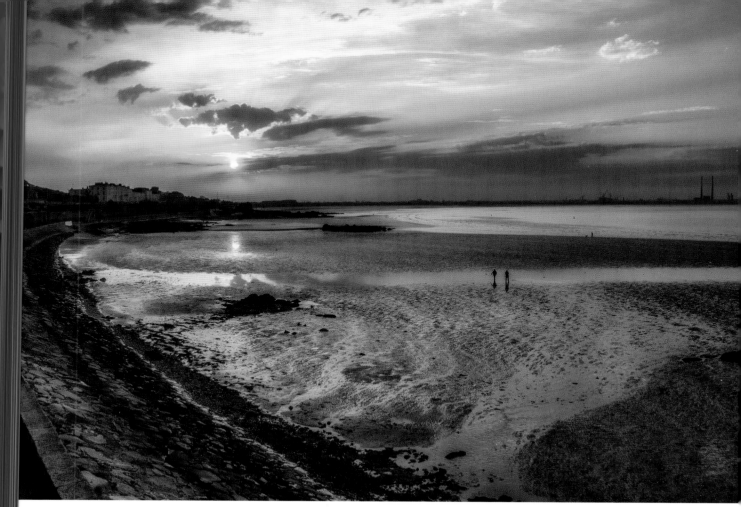

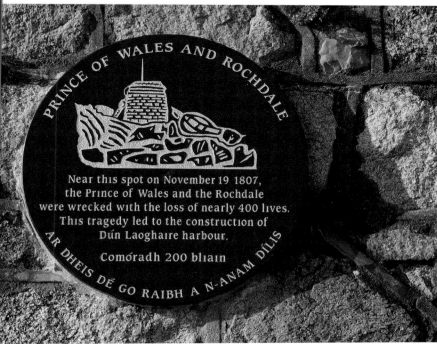

PRINCE OF WALES AND ROCHDALE

Near this spot on November 19 1807, the Prince of Wales and the Rochdale were wrecked with the loss of nearly 400 lives. This tragedy led to the construction of Dún Laoghaire harbour.

Comóradh 200 bliain

AR DHEIS DÉ GO RAIBH A N-ANAM DÍLIS

A cloud began to cover the sun slowly, shadowing the bay in deeper green. It lay beneath him, a bowl of bitter waters

James Joyce, *Ulysses*

DÚN LAOGHAIRE, SANDYCOVE AND GLASTHULE

The town of Dún Laoghaire, formally known as Kingstown, was born out of tragedy. Following the sinking of the *Prince of Wales* and the *Rochdale* ships in November 1807, which resulted in the loss of 400 lives, a campaign led to plans for the West Pier in Dún Laoghaire. Construction of, what would become, a major port of entry for Britain began in 1817. The opening of the Dublin to Kingstown Railway in 1834 led to the town becoming a thriving Victorian seaside resort. Many echoes of that era remain around Dún Laoghaire, including the octagonal bandstand on the East Pier and the traditional tearooms in the People's Park.

There is a long history of boating in the area. The harbour is home to the National Yacht Club (1870), the Royal St George Yacht Club (1838), and the Royal Irish Yacht Club (1831) – all with longstanding and proud histories – and boasts one of the largest marinas in Ireland. Each club runs sailing classes and hosts social and cultural events for their thousands of members. Regattas have long been part of the local calendar, with hundreds of yachts and other boats taking to the bay. The annual summer Dún Laoghaire Regatta is the most extensive of its kind in Ireland.

In keeping with this nautical tradition, the National Maritime Museum of Ireland is housed in the former Mariners' Church on Haigh Terrace in the town. For those without access to their own seaworthy vessel, Dublin Bay Cruises run scenic cruises between Dún Laoghaire and Howth.

If you wish to remain on dry land, Dún Laoghaire has much to offer. The East Pier has long been popular with walkers. The writer Samuel Beckett is said to have had an artistic epiphany at the end of the pier. On fine days large crowds can be witnessed at the small hatch of the iconic Teddy's as people queue for a traditional 99 ice cream cone. Should you desire something more substantial to eat, there are many restaurants on offer in Dún Laoghaire and the surrounding villages of Sandycove and Glasthule.

Following the promenade south along the coast brings you to Sandycove, made famous as the setting of the opening scene of James Joyces *Ulysses*. The Martello tower at Sandycove was home of another writer, Oliver St John Gogarty, from 1904–1925, and Joyce was a guest there for a brief period as a young man. Today the tower houses a Joycean museum.

Sanycove's other claim to fame is the gentleman's swimming club at the Forty Foot. For over 200 years this area was strictly men only. Due to this fact and the relatively secluded location, it became popular with nude swimmers. In the 1970s the area opened up to women and children, and it remains a favourite, year-round swimming spot. Whilst most swimmers nowadays come appropriately attired, it is not uncommon to encounter the odd nude swimmer, some who have been known to fall victim to the overly curious, local seal population.

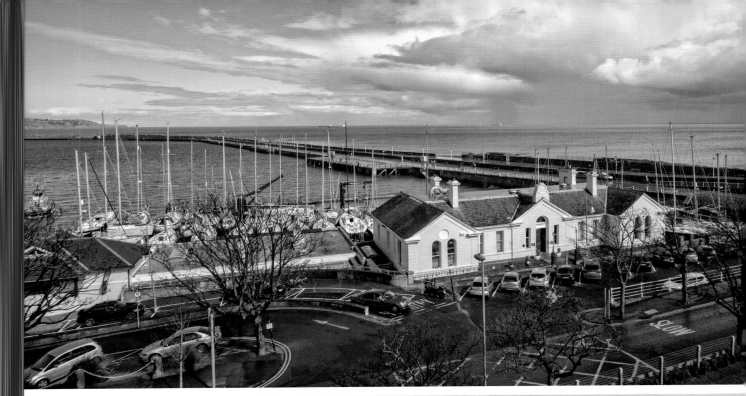

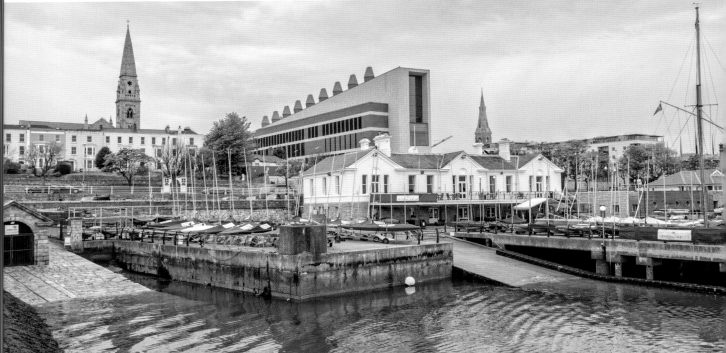

Top: Looking out across Dún Laoghaire's East Pier to the **National Yacht Club**.

Bottom: Looking back from the East Pier with the **National Maritime Museum of Ireland**, which is housed in the former Mariners' Church, and **DLR Lexicon** in the background.

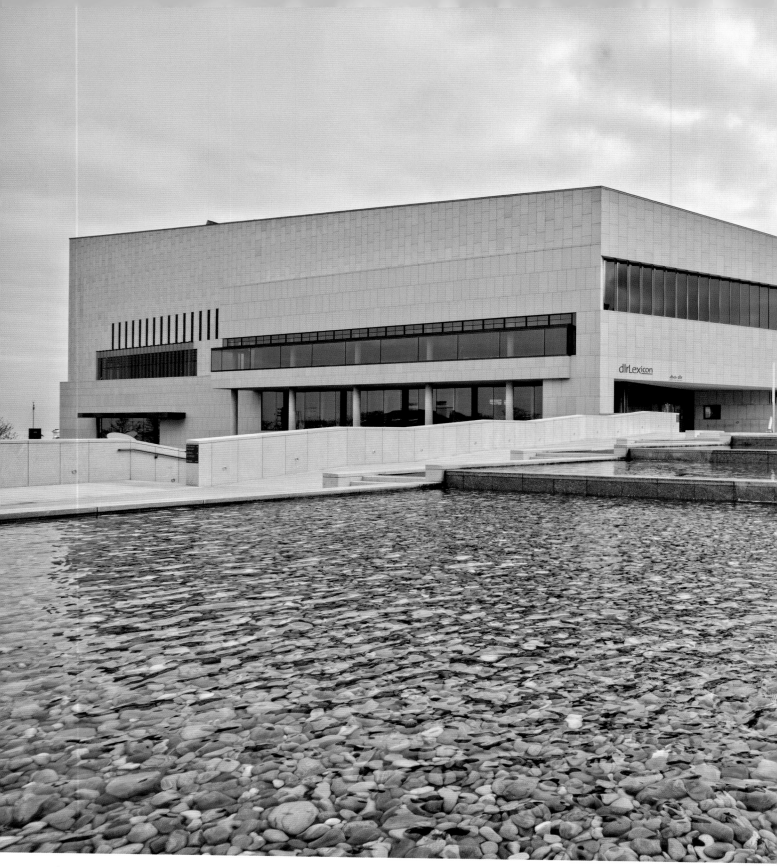

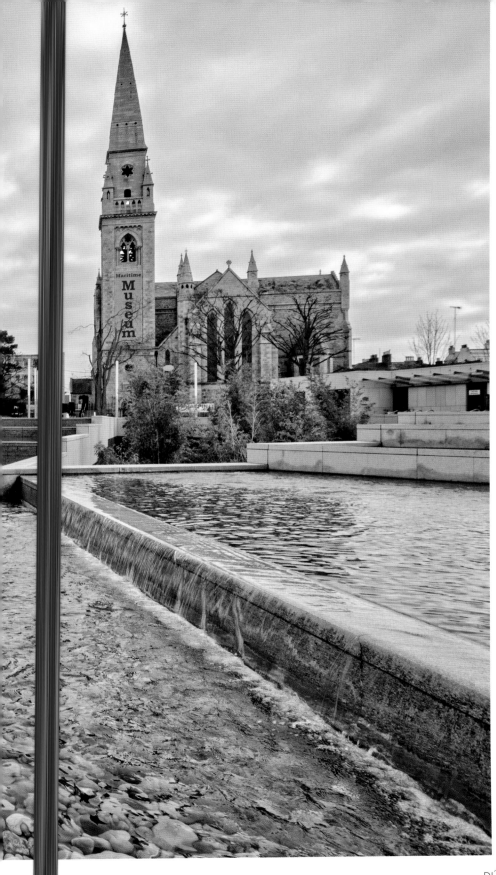

Old meets new: The **DLR Lexicon** and the **National Maritime Museum of Ireland**.

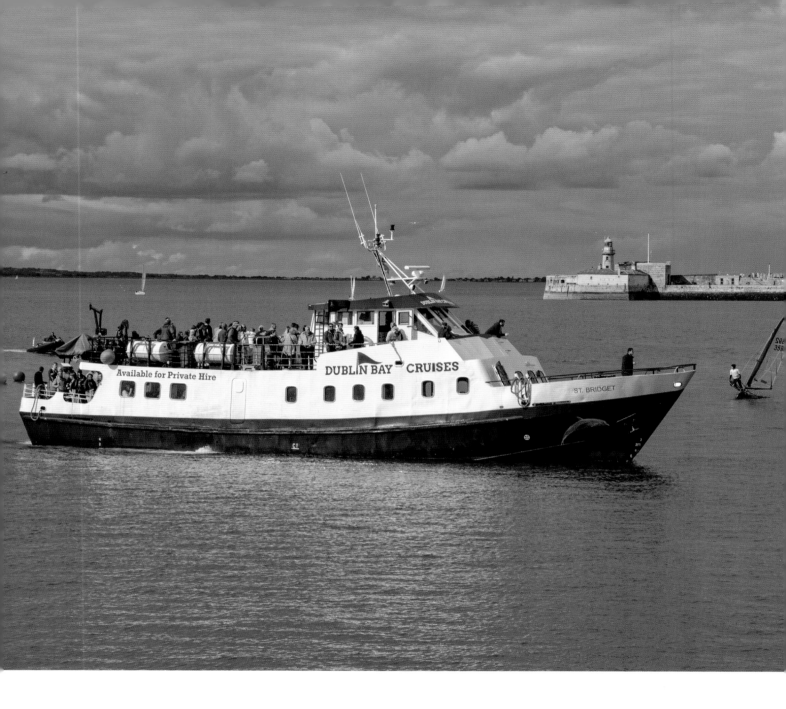

Above: For a wonderful day out on the waters of the bay, **Dublin Bay Cruises** sail between Dublin city, Dún Laoghaire and Howth seven days a week during the months April to October.

Right page: The Baily Optic from The Baily Lighthouse on Howth Head was installed in 1902 and removed in 1972 when the lighthouse was modernised. The light was equivalent to 2,000,000 candle power. It now shines a lesser light in the National Maritime Museum.

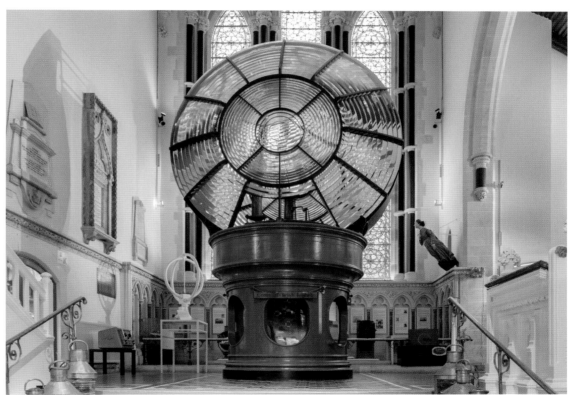

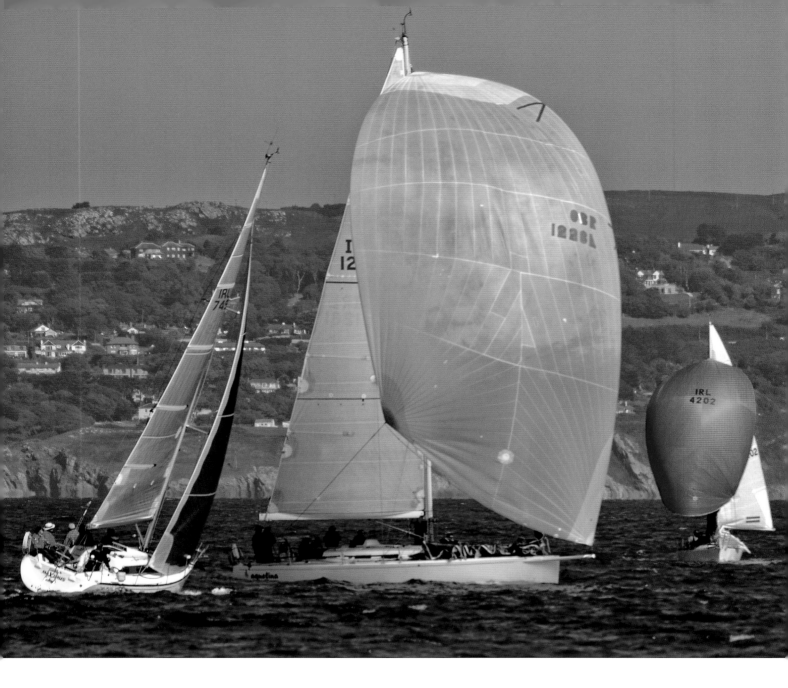

Above: Yachts off **Dún Laoghaire**, sailing at full speed, with their spinnaker sails powered by the elements. As on busy roads, strict rules apply at sea.

Right page, top: Accessible at all stages of the tide, the **marina** in Dún Laoghaire, which opened in 2001, is one of largest marinas in Ireland, with over 800 berths to suit boats from 6 metres to 45 metres in length, making it a key harbour for visiting craft.

Right page, bottom: Preparing to start the race. Different classes of **yacht** have separate starts – from left: Shipman class, Flying Fifteen, a squib (with the red sail) and another Shipman alongside. In the middle distance, between the Shipman and the Flying Fifteen, *The Freebird*, Dublin Bay Committee's boat, can also be spotted.

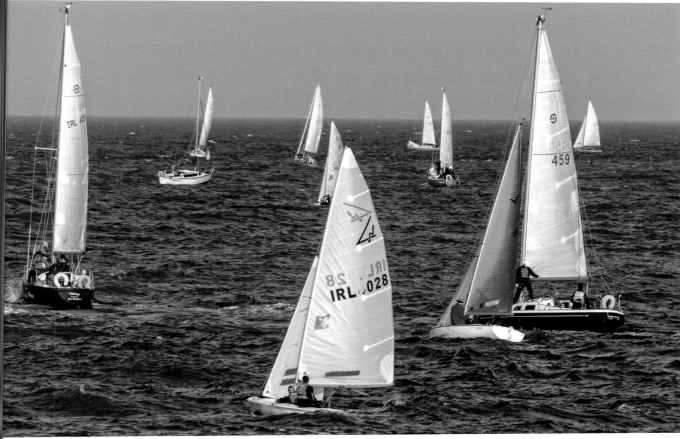

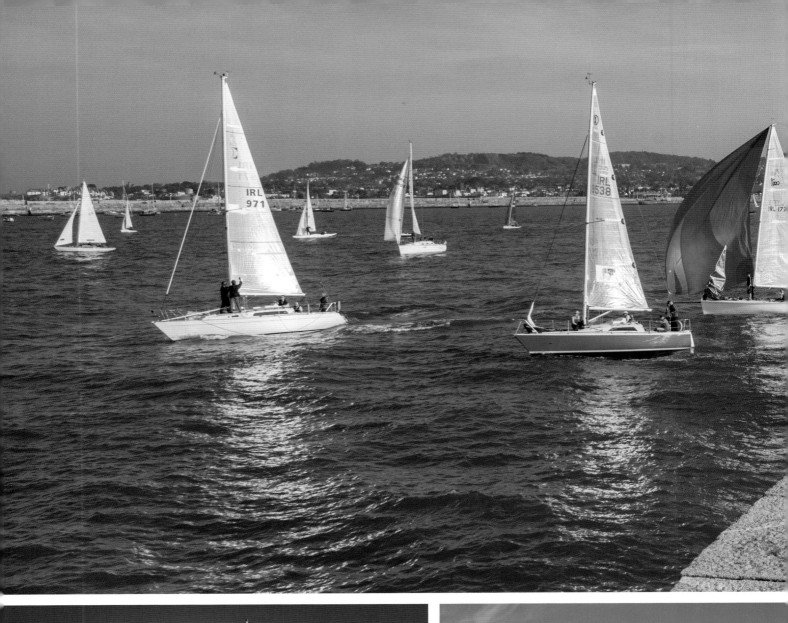

Dún Laoghaire Harbour has a number of sailing clubs: the National Yacht Club, the Royal Irish Yacht Club **(bottom left)**, the Royal St George Yacht Club **(bottom right)**, along with the Dún Laoghaire Motor Yacht Club (1965) The Royal Alfred Yacht Club (1857), and the Irish National Sailing & Powerboat School (1972). Many other water-based sports, such as rowing, windsurfing, fishing and swimming, also thrive in the harbour and its surrounds.

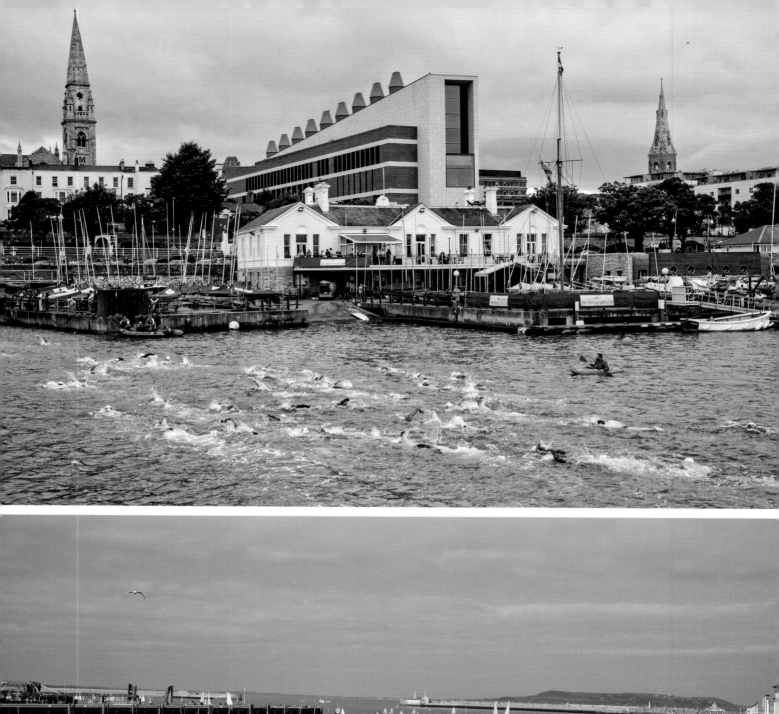
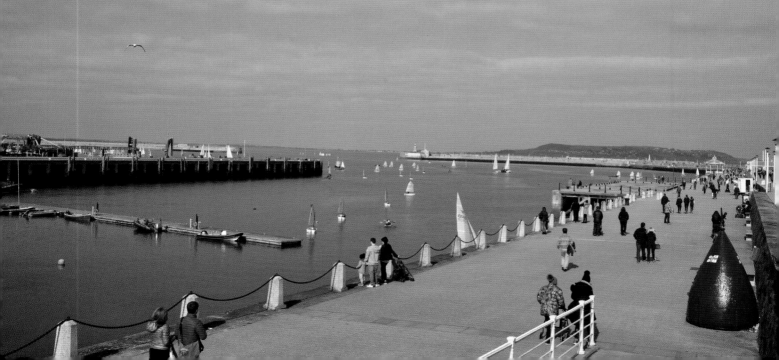

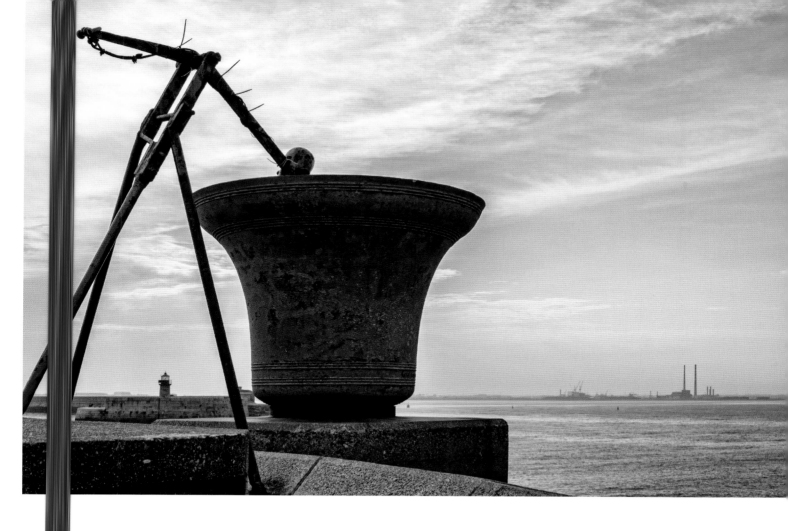

Abo... The **Fog Bell** in the Battery at the end of the East Pier, with the distant outl... of Dublin Port. A plague nearby reads: The original fog bell (1850) was repl... in September 1852 in a tall wooden belfry to the east and outside of the ... ry. This bell is inscribed 'Sheridan Dublin Maker 1852'.

Left ... e, top: The **Harbour Swim** passing by the National Yacht Club.

Left ... e, bottom: The harbour is one of the largest in the country and is n... e for its two granite piers; the **East Pier** is particularly popular with wal... with its 2.6-kilometre return walk. The dark form of Howth Head can be s... on the horizon, across the bay.

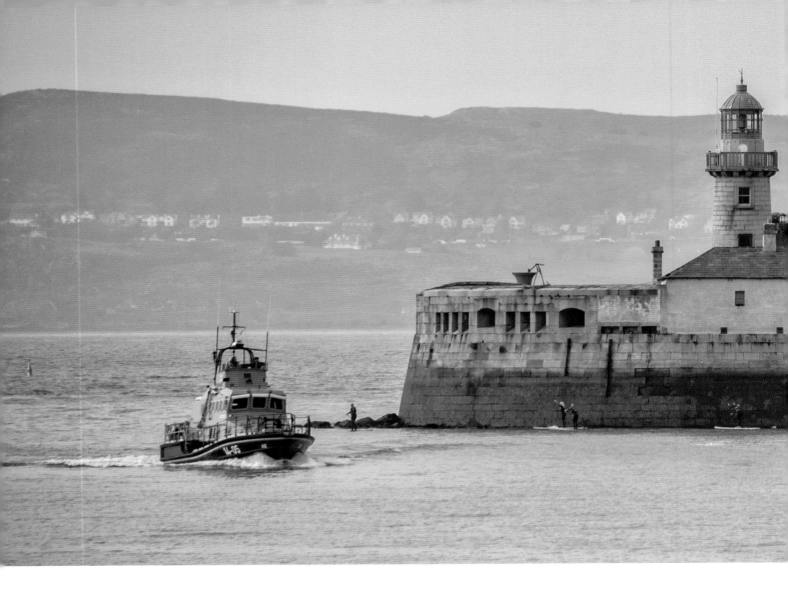

Above: The **East Pier Battery** is one of only two gun saluting stations in the country, Spike Island in Cork being the other. Army gunners use it to fire salutes for visiting naval ships. This shot taken from the West Pier shows the Dún Laoghaire lifeboat coming home after exercises.

Right page, bottom left: All around **Dublin Bay** on warm summer days teenagers can be seen jumping off piers, bridges and buildings, daring one another to have a go.

Right page, right: The lighthouse at the end of the **West Pier** with the lighthouse and battery of the East Pier in the background. The West Pier is the perfect place for a quiet walk; it is slightly longer than the East Pier and has a lighthouse and a keeper's house at the end.

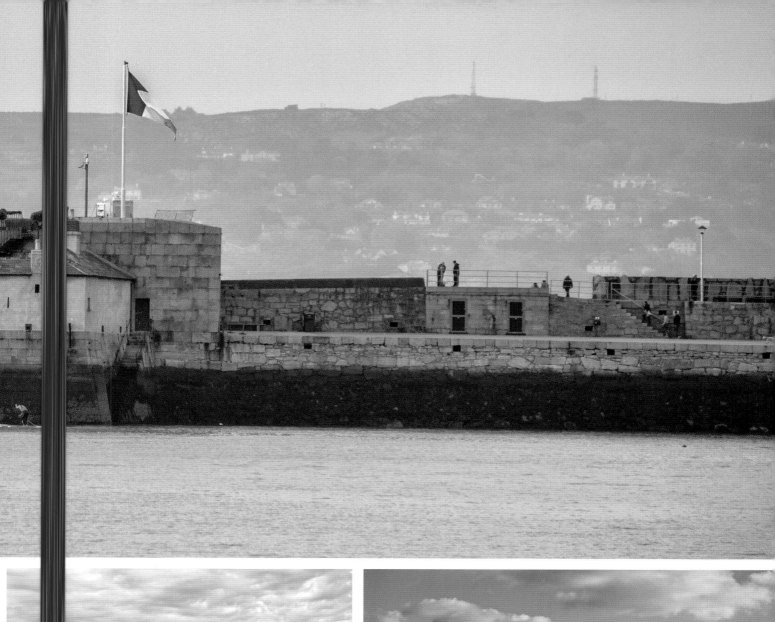

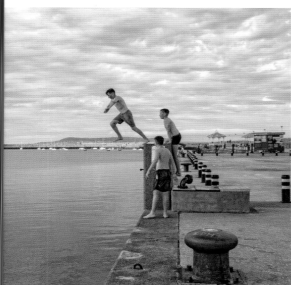

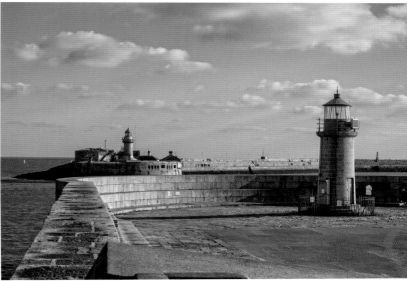

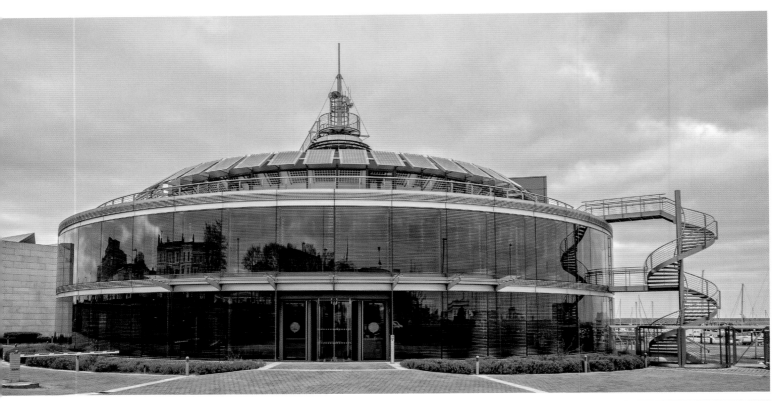

Top: Designed to ressemble a beacon, the landmark, modern headquarters of the **Commissioners of Irish Lights**, houses a maritime organisation, with a 200-year-old history, tasked with essential safety and support for Irish coastal communities. In the 19th century their work centred on lighthouses, lightships, buoys and beacons; today, their work encompasses modern technologies, such as their Global Navigation Satellite Systems and sustainable energies for the automated lighthouses.

Bottom: The **Pavilion** playground with its pirate ship forms part of the urban renewal along the Queen's Road, which includes shops, cafes with outdoor spaces, and the DlR Lexicon, housing the Central Library and Cultural Centre.

Right page: Opposite the town hall, the **Queen Victoria Fountain** was erected in 1900 to commemorate the royal visit to Ireland. It was neglected after Ireland gained independence but was restored in recent times.

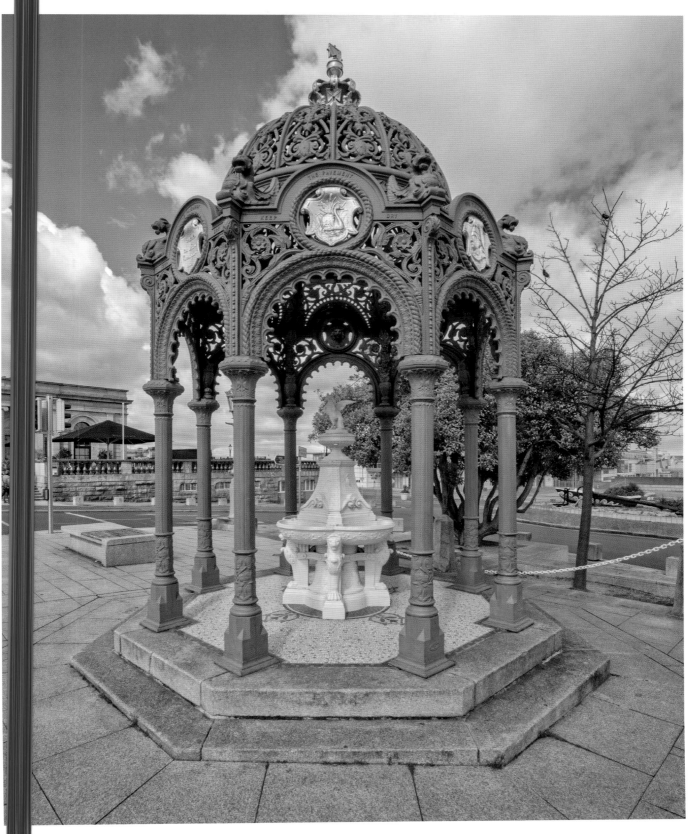

Above and right page, bottom right: The **People's Park**, a perfect venue for open-air cultural events and the lively Sunday market, is a fine example of a Victorian park, with beautiful flowerbeds, gate lodge, tea rooms and restaurant, fountains and a playground.

Right page, top: For generations of visitors to Dún Laoghaire, since 1950, no visit would be complete without a **Teddy's** ice cream.

Right page, bottom left: Eddie Gahan in the headquarters of **The Genealogical Society of Ireland**, at Carlisle Pier, Queen's Road – a great place to delve into family history.

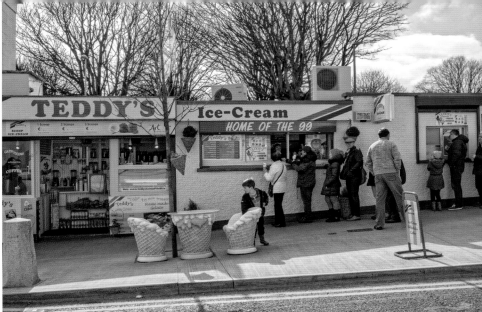

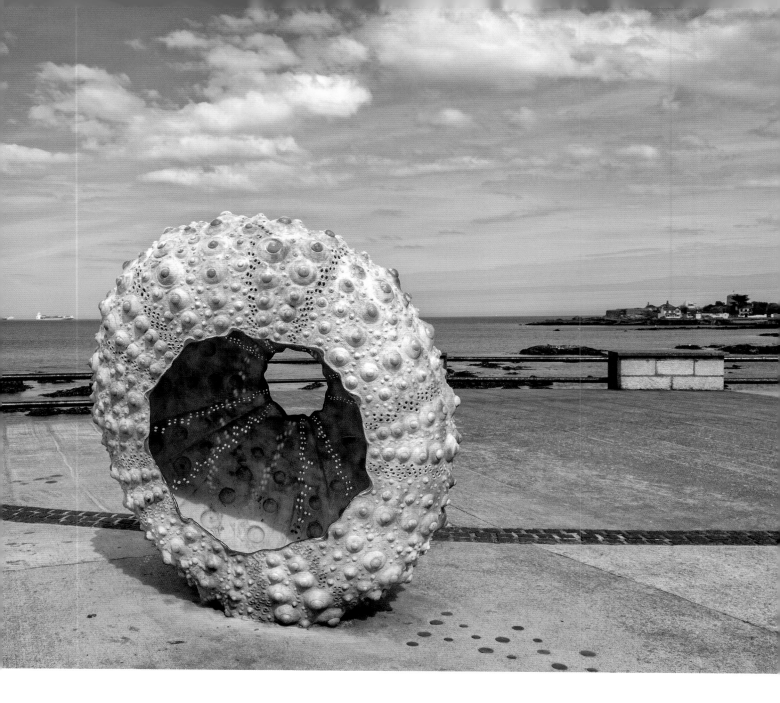

SANDYCOVE AND GLASTHULE

Above: *Sea Urchin* by Rachel Joynt is one of the most popular pieces of sculpture around Dublin Bay, much loved by children and adults alike.

Right page, top: Dalkey Rowing Club preparing for their annual regatta in **Scotsman's Bay**.

Right page, bottom: Big furniture, drawing the curious, at the '**Big Day Out**' event on the promenade in front of Scotsman's Bay.

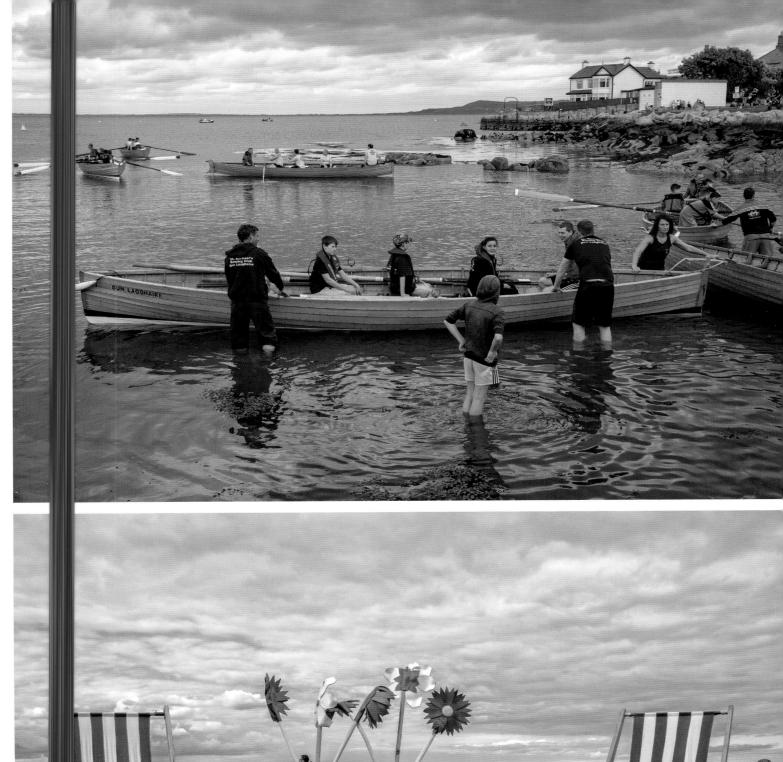

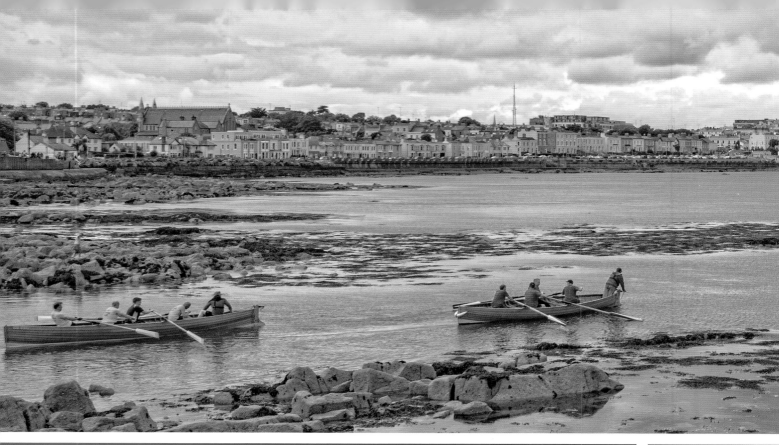

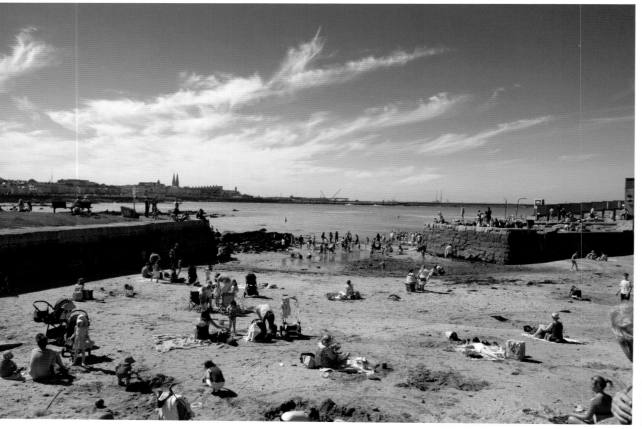

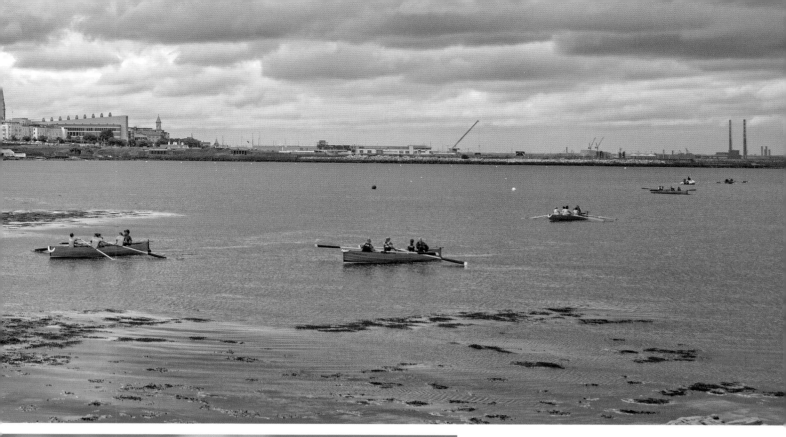

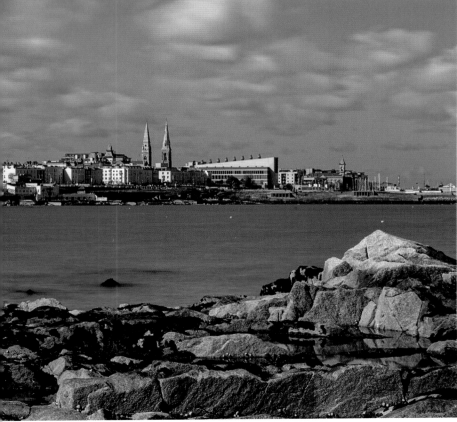

Top: Looking back across **Scotsman's Bay**, on Regatta day, towards Dún Laoghaire and the Poolbeg Chimneys from Sandycove Beach.

Bottom right: A view of Dún Laoghaire from rocks at **Sandycove Beach**.

Bottom left: When the sun shines, crowds take to the sand and waters of **Sandycove Beach**.

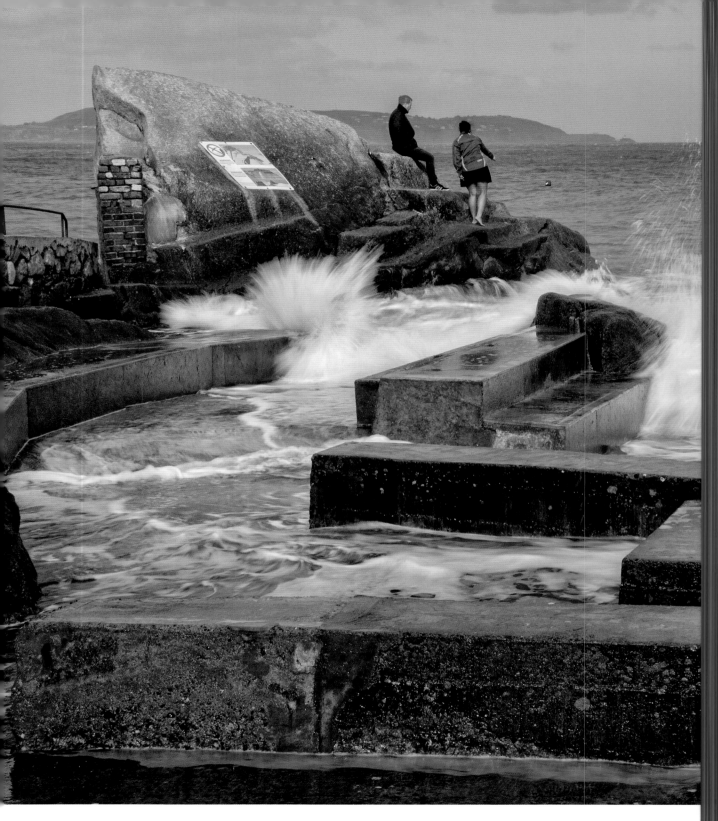

Above: A windy day at the **Forty Foot**. **Right page, top:** Looking south towards Bulloch Harbour, the Kennedy sisters test the water at the **Forty Foot**. **Right page, middle:** The **Forty Foot** with the **Martello tower**, made famous by James Joyce in *Ulysses*, and the 'White House', designed by architect Michael Scott.

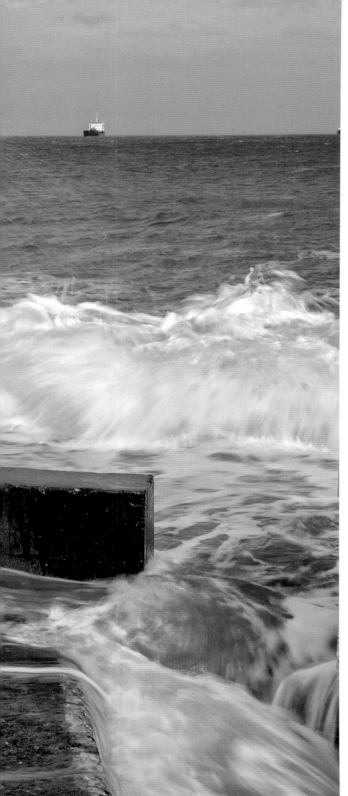

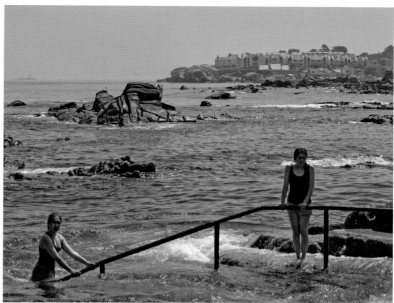

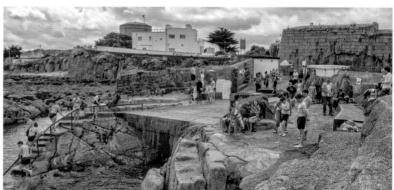

Bottom: The **Forty Foot** is a promontory just south of **Sandycove Beach**. People have been swimming here all year round for at least 250 years. In the past it was exclusively a gentlemen's bathing place and a popular spot for nudists; today it is all inclusive. The water is furiously cold but clean and bracing.

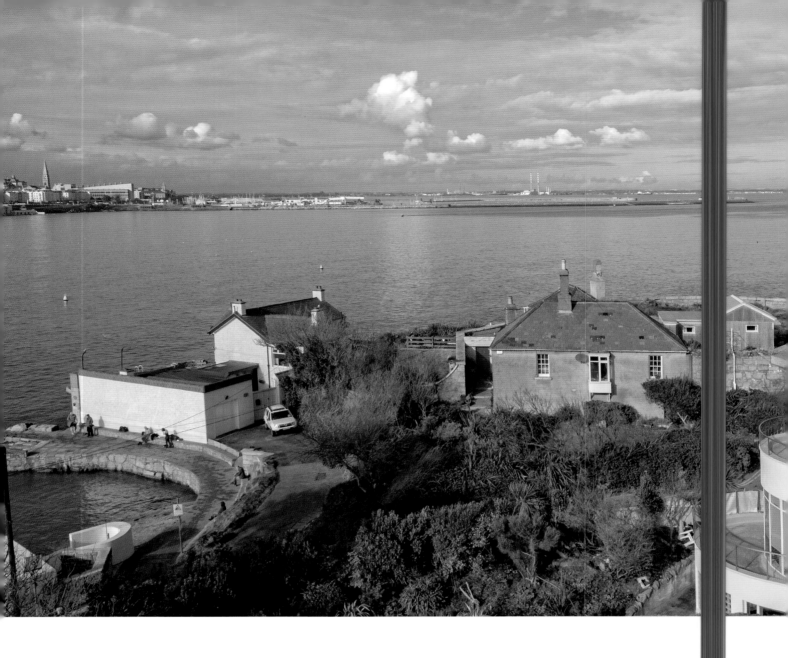

Above: A sweeping view of the bay from atop the Martello tower of the **James Joyce Museum**.

Right page: Inside the **James Joyce Tower and Museum** are displays of some of his possessions and items associated with *Ulysses*. Open all year round, you get a friendly welcome from the volunteers that run it, and it is free. This room is set up to resemble its 1904 appearance and the opening chapter of *Ulysses*.

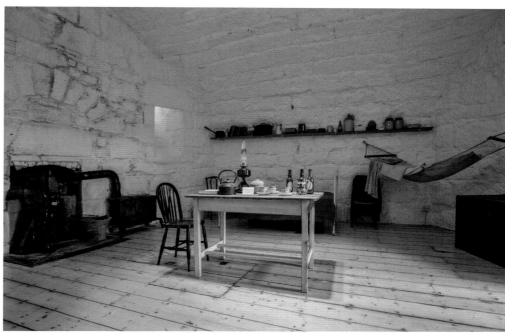

Top: Music, period food and vintage dress are de rigueur for **Bloomsday**, a highlight on Dublin's literary event calendar when homage is paid to James Joyce's *Ulysses*.

Bottom: **Cavistons** food emporium and restaurant, Glasthule, one of the best known seafood restaurants that are scattered all around Dublin Bay.

Right page: Celebrating Bloomsday (16 June) in style in **Glasthule**.

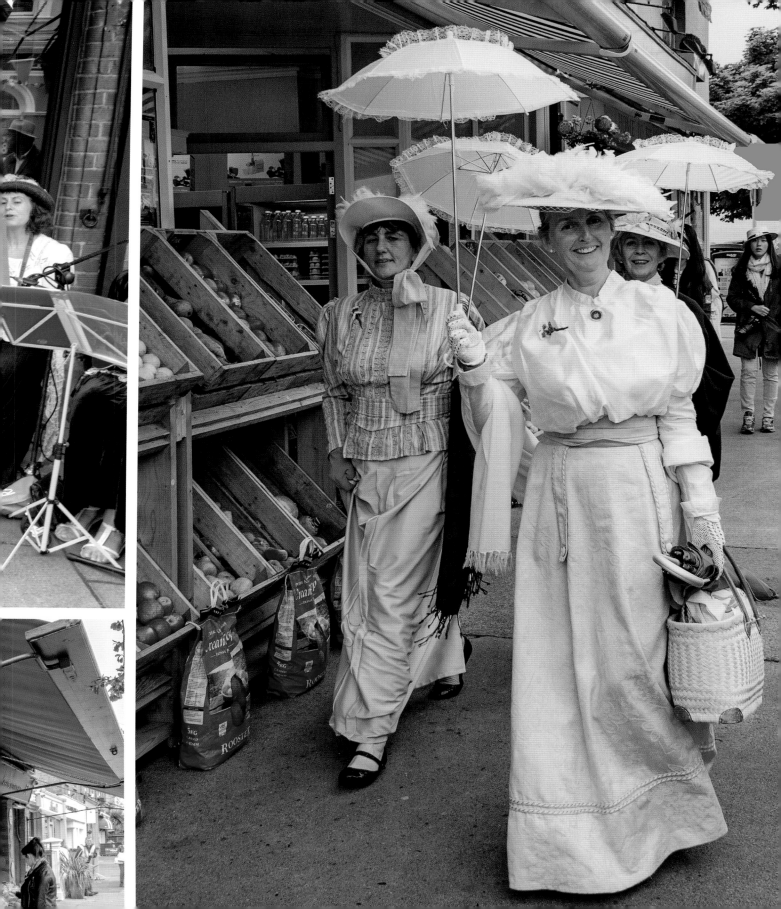

a little town with two magic harbours, and hills and views without equal in the land

Maeve Binchy on her beloved Dalkey

DALKEY

The village of Dalkey is steeped in history. Signs of human habitation dating back to Mesolithic times have been discovered on Dalkey Island, just five minutes offshore. The village itself was originally settled by the Vikings, and owing to the silting of the River Liffey in the middle ages the harbours in Dalkey became some of the most important in Dublin. Goat Castle on Castle Street, one of three castles remaining in the village is home to Dalkey Heritage Centre. Here, through a series of interactive exhibits, one can immerse oneself in the history and culture of this unique part of Dublin.

Dalkey is home to two harbours: Coliemore to the south and Bulloch to the north. Coliemore Harbour is arguably the more picturesque, with views out over Dalkey Island. Renowned for its lobster and crab fishing, Coliemore was once the main port for Dublin city. Bulloch Harbour is popular with visitors due to its thriving seal population and is a designated seal sanctury. Boat trips to nearby Dalkey Island run from both harbours, and a trip to the island is well worth the five-minute boat ride.

Dalkey Island sits a mere 300 metres offshore. Currently uninhabited (unless you count the wild goats), there is evidence of human life on the island more than 6,000 years ago. Numerous artifacts from across the ages have been collected and are now housed at the National Museum of Ireland. Visitors to Dalkey Island can explore the remains of St Begnet's Church, dating back to the 7th century, or wander round the Martello tower. In the 18th century Dalkey Island elected its own ruler, 'His facetious Majesty, King of Dalkey, Emperor of the Muglins (rocks nearby), Defender of his own Faith and respecter of all others and Sovereign of the illustrious Order of the Lobster and Periwinkle.' Today, the area is a popular with anglers, sailors and kayakers.

Dalkey is a charming and bustling village, with many independent shops, artisan restaurants and fine pubs. Former US first lady Michelle Obama, and her daughters, spent an evening at Finnegan's Pub in Dalkey whilst on an offical visit to Ireland in 2013. Writers such as Hugh Leonard and Maeve Binchy called Dalkey home and added to the rich cultural heritage this area enjoys.

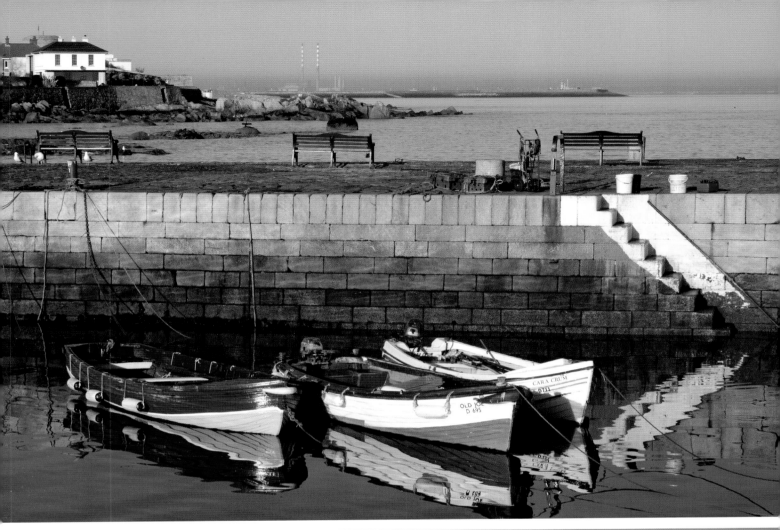

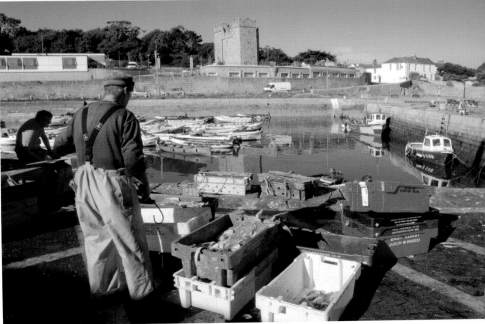

Top: Bulloch Harbour, at the Sandycove end of Harbour Road in Dalkey, is a working harbour for local fishermen and boat hire. Lobster and crabs are landed there, and it a perfect spot to watch birds and the seals who follow the boats. The harbour is constructed of local granite, cut from the nearby Dalkey Quarry.

Bottom: Sorting the fish in **Bulloch Harbour**, with the imposing Norman **Bulloch Castle** in the background.

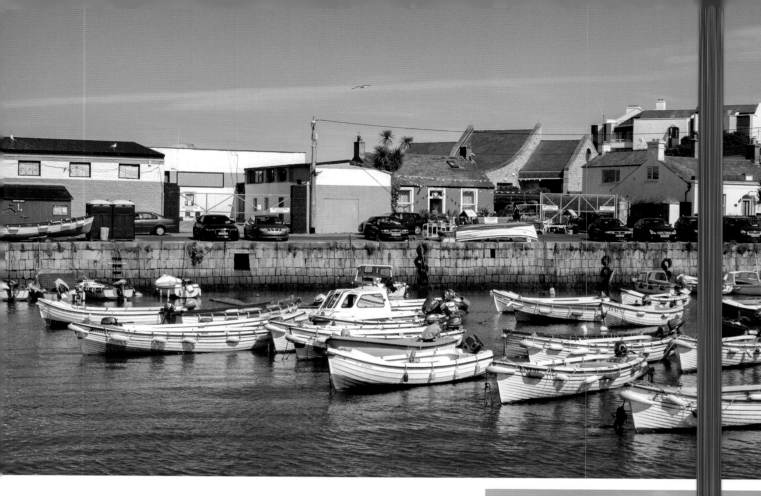

Top: Boats in **Bulloch Harbour**. Kayaking tours and classes operate out of the harbour.

Bottom: Dogs on the lookout as canoes head out from **Bulloch Harbour**.

Right page, top: Goat Castle, which is today part of **Dalkey Castle and Heritage Centre**, is one of the original seven Anglo-Norman castles of Dalkey. Visitors can still see the murder hole and battlements. Today, the Heritage Centre consists of the restored castle, an early Christian church and graveyard, and the Writers' Gallery, with information on 45 writers and creative artists. Guided tours use actors to bring history to life. Dalkey, home to many famous writers over the years, such as James Joyce, Samuel Beckett, Hugh Leonard, Maeve Binchy, and songwriters such as Van Morrison, also hosts literary walking tours and the Dalkey Book Festival during the summer months.

Right page, bottom: The main upper room, **Dalkey Castle**.

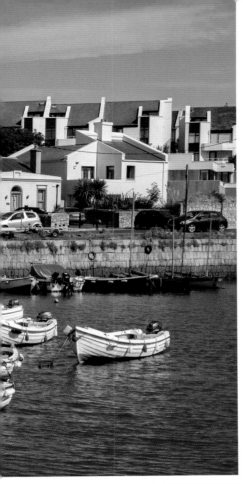

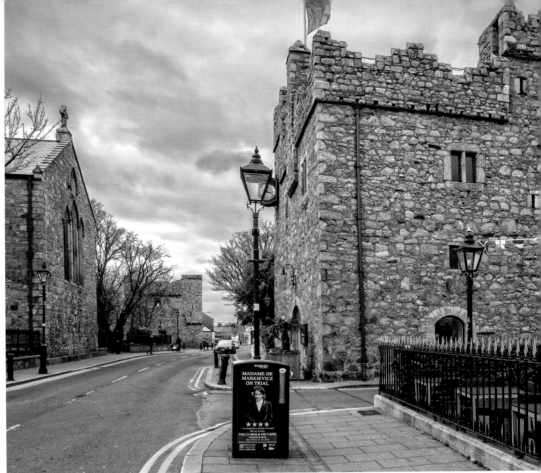

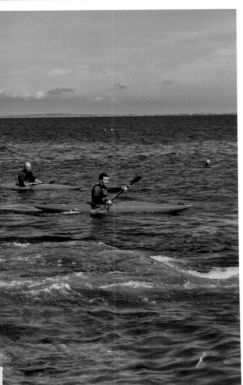

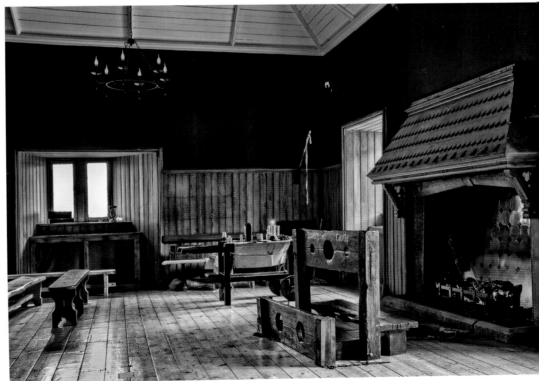

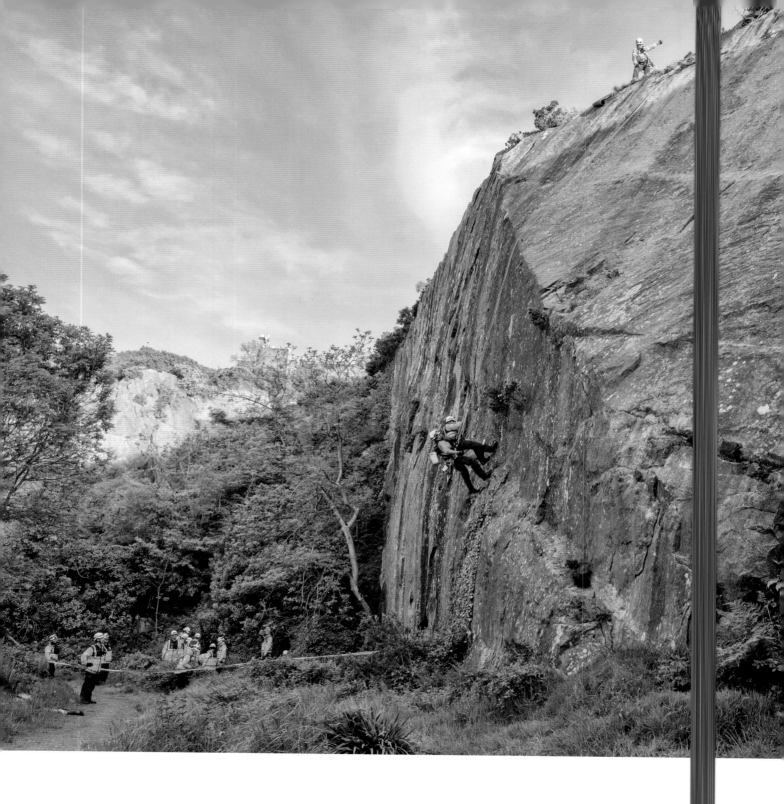

Above: The Irish Coast Guard training for cliff rescue in **Dalkey Quarry**. In early 1815 quarrying started on Dalkey Hill in order to supply granite for the construction of the new harbour and pier at nearby Dún Laoghaire, as well as for the construction of the South Bull Wall. Quarrying continued until 1917, and then the quarry became part of Killiney Hill Park. With just one path and one set of steps, the quarry was left wild so wildlife could thrive. Today it is also used by practising climbers.

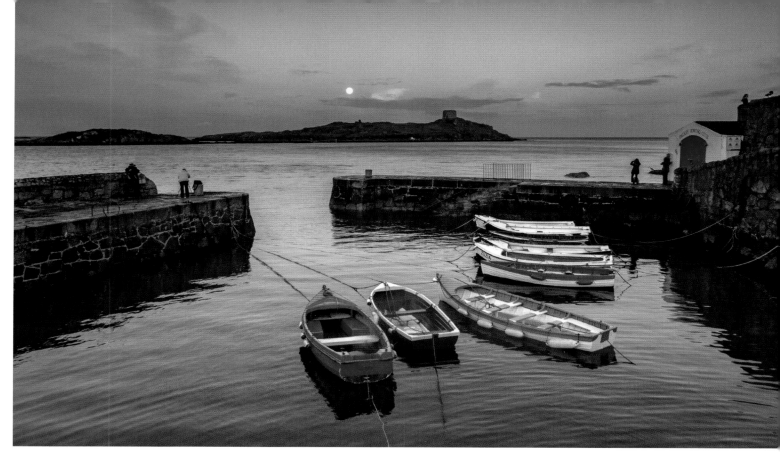

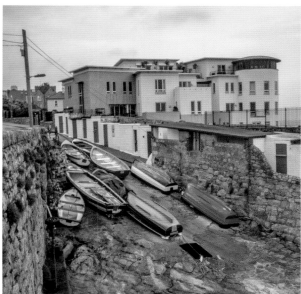

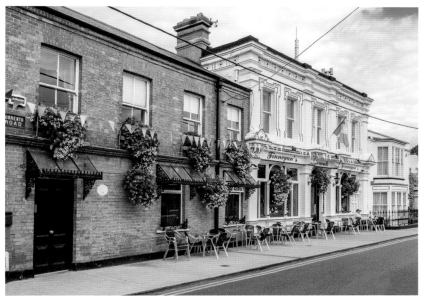

Top: Coliemore Harbour frames a beautiful moonrise over Dalkey Island.

Bottom left: Coliemore Harbour, a much smaller harbour than Bulloch Harbour, but very picturesque. The harbour lies in the southern part of Dalkey, overlooking Dalkey Island, and during summer months a ferry runs between the island and harbour.

Bottom right: Finnegan's pub, a one-time favourite haunt of the writer Maeve Binchy, remains true to its heritage and is largely unspoiled; nearby, there are art galleries, bookshops, restaurants, other pubs, shops and parks to enjoy.

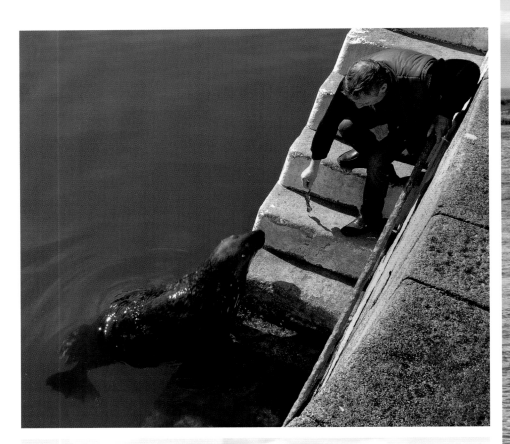

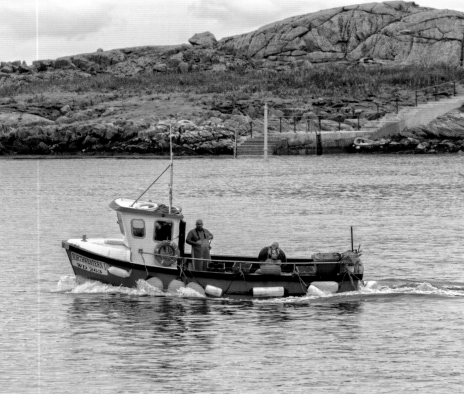

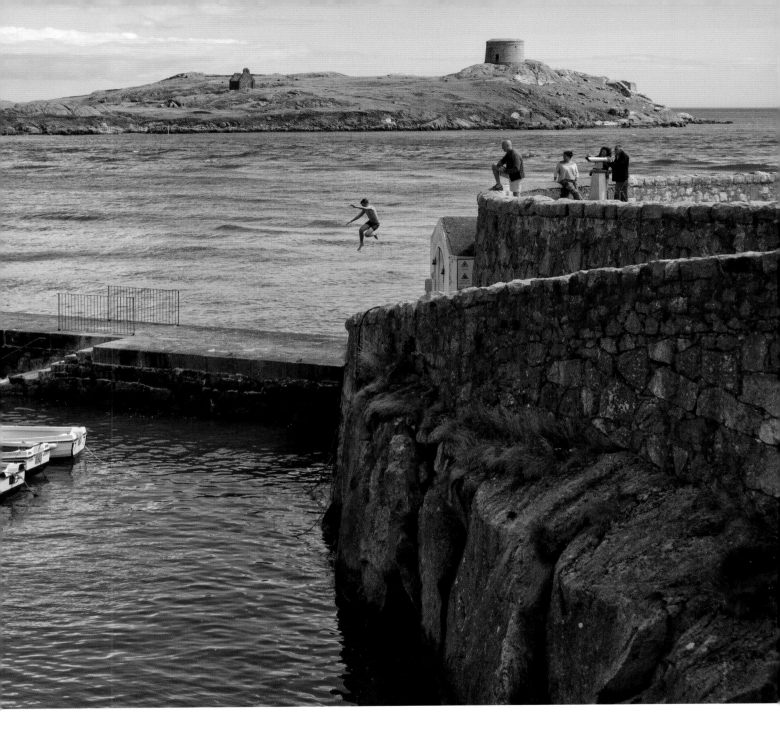

Above: Pier jumping on a summer's day at Coliemore Harbour, with Dalkey Island in the background. In medieval times Coliemore was a main harbour for Dublin city.

Left page, top: Come and get it! A seal being fed on the steps in **Bulloch Harbour**. Dolphins have also been known to visit this part of the bay.

Left page, bottom: A trawler coming home past **Dalkey Island**. In 1958 excavations found evidence of early life on the island, dating back to 4500BC. The three small islands to the north are Lamb Island, Clare Island and Maiden Rock. The waters around Dalkey Island are used for sailing, angling and diving.

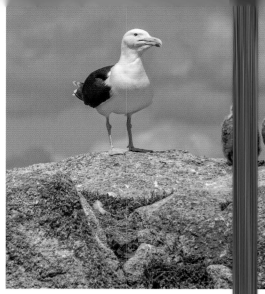

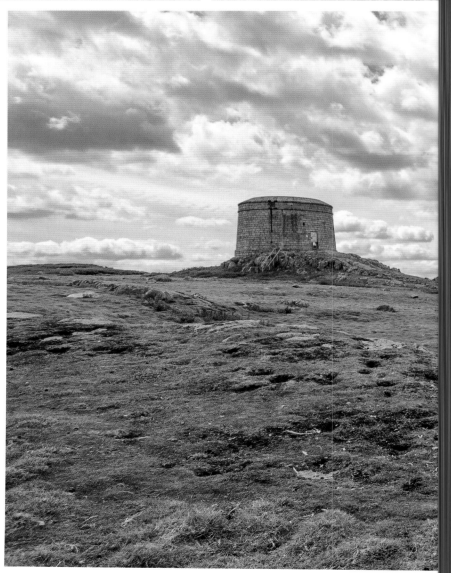

Top left: Catching mackerel at **Dillon Park**, Dalkey.

Top middle and right: Great black-backed gulls on **Dalkey Island**, a bird watcher's paradise. Care is needed as the ground is riddled with rabbit holes and there is a colony of wild goats. During the summer months a regular ferry runs to the Island. Dalkey Scubadivers go diving and snorkelling off the island and further afield.

Bottom: **St Begnet's Church** on Dalkey Island is thought to have originated as a timber structure in the 9th or 10th century, and is believed by some to offer miracle cures from its nearby Holy Well. There are unusual carved stone crosses nearby, and the **Martello tower** on the island is one of the best preserved examples of its kind.

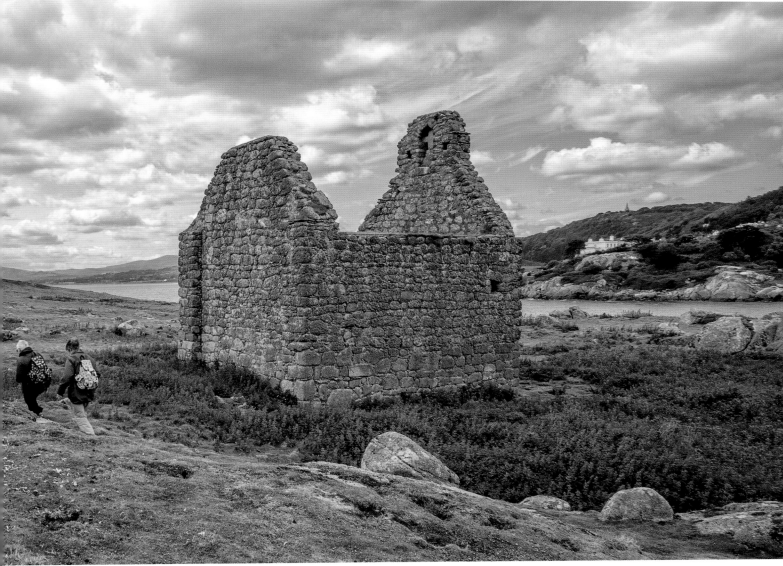

KILLINEY

The hilly terrain and stunning sea views that can be enjoyed along this section of the Dublin Bay coastline have led to comparisons with the Bay of Naples. It may be for this reason that many Irish and international celebrities such as U2 frontman Bono and singer Enya have chosen to make this village at the southern-most reaches of Dublin Bay their home.

The ruins of Killiney Church, which dates back to the 11th century can still be seen on Marion Road West. Killiney remained very much a rural outpost of Dublin until the extension of the Kingstown Railway in the 19th century. Today the DART runs along the coast, allowing passengers a sweeping view of the bay on one side and an opportunity to spy into the gardens of the many grand houses that overlook the sea on the other.

Killiney Hill Park, also known as Victoria Park, became a public park and was dedicated to Queen Victoria in 1887 as part of her Jubilee celebrations. The summit sits some 153 metres above sea level and rewards those who make it to the top with some truly spectacular views of Dublin Bay. The hill is topped by an obelisk, which was commissioned, in 1742, by local landlord John Mapas, in memory of local victims of the famine 1740–1741.

Killiney Castle was acquired by the Fitzpartrick family in the 1970s. The castle was originally built by the Mapas family in 1740, at which time it was known as Mount Mapas. It was taken over by Robert Warren, in 1840, who extended and extensively restored the building. Following the renovations, it became known as Killiney Castle, and today it is run as a hotel.

The pebble beach at Killney has Blue Flag designation and is popular with swimmers all year round, although winter swells and the occasional influx of jellyfish can make it unsafe at times. In 2010 a pod of bottlenose dolphins was first spotted in the waters around Killiney. The area is also a good place to spot seals.

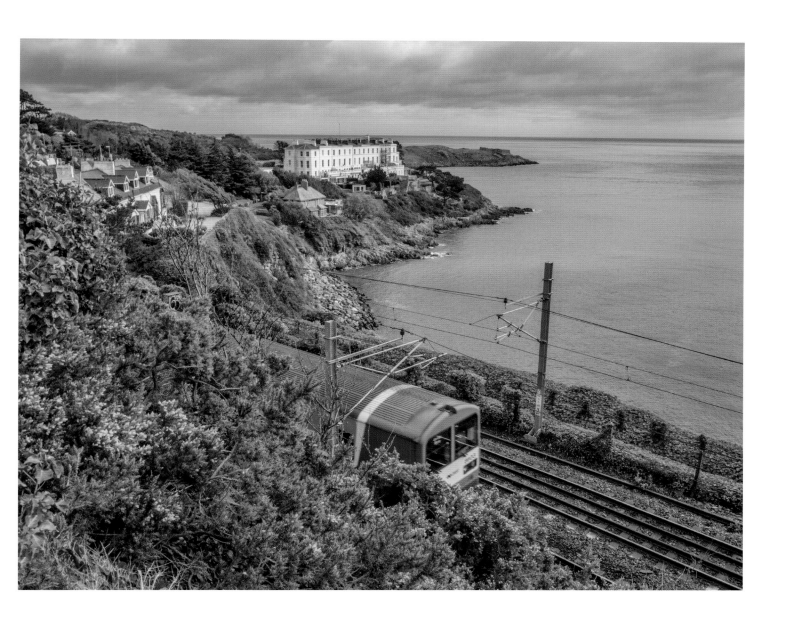

A view from **Killiney Hill Park** with the elegant row of Regency
houses of Sorrento Terrace rooted in the rocky outcrop of Killiney
Head. The coastal areas of Killiney have been compared to the Bay of
Naples for its stunning scenery; on a clear day the Mourne Mountains
can be seen far to the north.

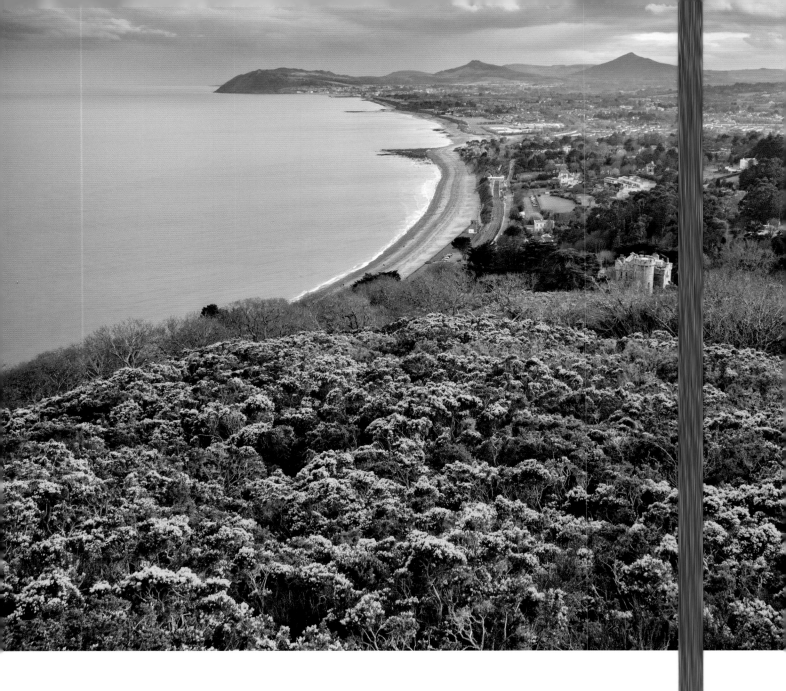

Above: Looking south towards the cones of the Great and the Little Sugar Loaf mountains in County Wicklow from **Killiney Hill**.

Right page: The **obelisk** on top of Killiney Hill commemorates the famine 1740–41 – the 'forgotten famine', caused by a very cold winter that destroyed livestock and food. Killiney and Dalkey hills are both part of Killiney Hill Park; in 1887 it was opened for public use by Prince Albert, in memory of Queen Victoria's Jubilee. The Park has many walking tracks and spectacular views in all directions.

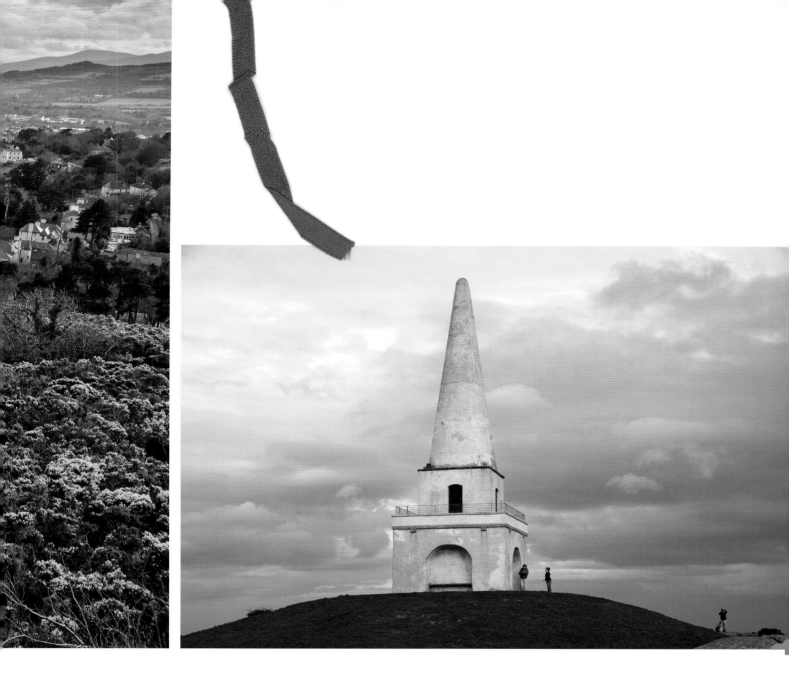

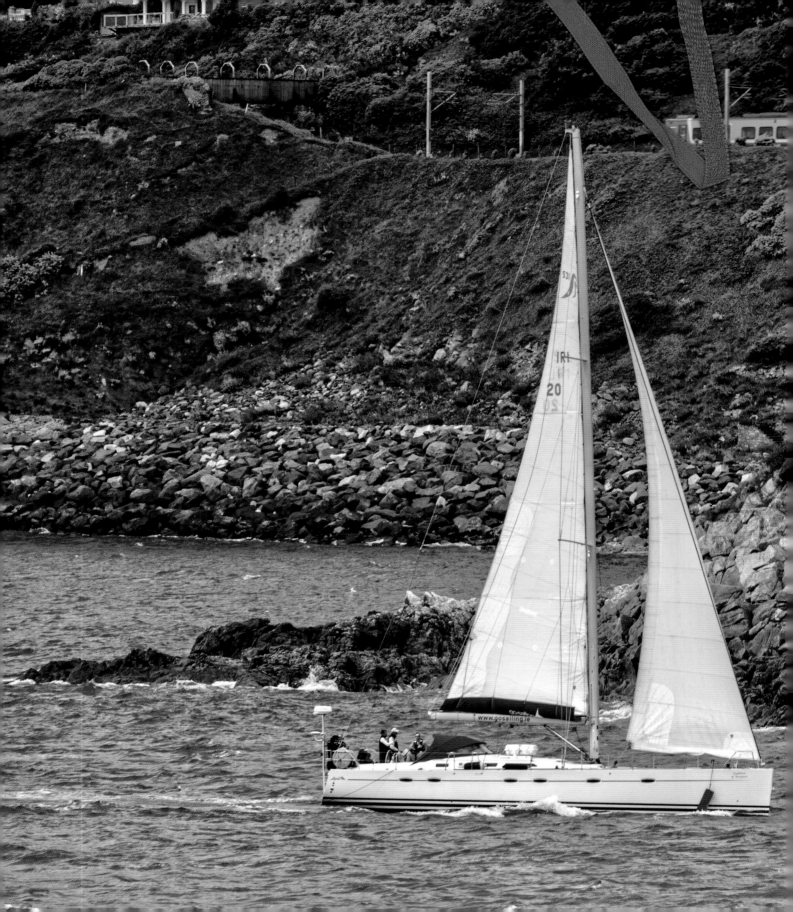

A hired Gosailing boat, out of Dún Laoghaire, passing **Killiney Hill**, with the DART running round the hillside.

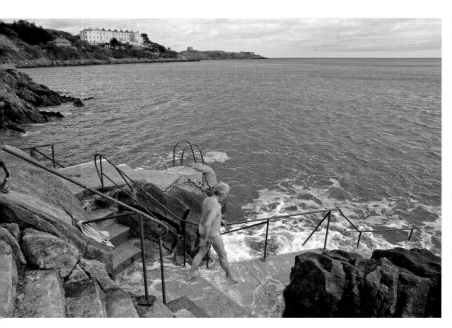

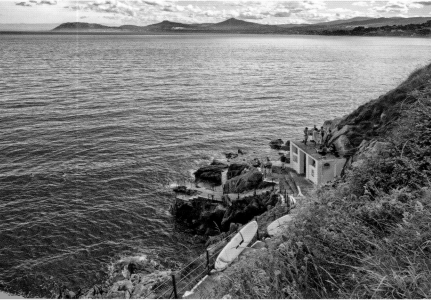

Top: A brave soul going swimming at **Hawk Cliff**.

Bottom: The view south to Bray Head from **Hawk Cliff** bathing and boat hut.

Right page: A moody shot of **Whiterock Beach** (accessed off the Vico Road, and a popular swimming spot) near Killiney DART Station.

> **"**
>
> … looking towards the blunt cape of Bray Head that lay on the water like the snout of a sleeping whale
>
> *James Joyce, Ulysses*

BRAY

The seaside town of Bray, with its esplanade and bandstand, sits on the border between Dublin and Wicklow. In medieval times it formed the southern border of The Pale, the area which was under direct English rule. The extension of the Dublin–Kingstown railway in 1854 saw Bray become the largest seaside resort in Ireland, and it remains a popular destination for day-trippers.

From the harbour, once primarily the landing point for coal imports and fishermen and now home to Bray Sailing Club and a colony of mute swans, a traditional Victorian promenade runs for a just over 1.5 kilometres along the pebble beach towards Bray Head. The 240-metre climb to the cross at the summit is well worth the effort for the spectacular views of Dublin Bay and surrounding areas.

Back at sea level, this seaside resort has plenty to offer. The National Sea Life aquarium sits on the shoreline and amusement arcades continue to entertain young and old. The seafront comes alive in the summer for the Bray Summerfest, an annual festival, the highlight of which is the Bray Airshow. In recent years tens of thousands of people have gathered on the beach to watch stunning displays by the likes of the Red Arrows.

Numerous bars and restaurants line the promenade, many of which have outdoor seating to make the most of the seaside location. The Harbour Bar, at the northern end of the promenade, was named The Best Bar in the World by Lonely Planet in 2010. It is a cosy pub, with live music and an eclectic clientele – the perfect place to relax and refresh.

Away from the seafront, is Bray Main Street, a vibrant shopping experience, and, within walking distance, is Kilruddery House and Gardens. Originally built in the 17th century, it has been in the Brabazon family for generations and remains today a working house and farm. An afternoon is well-spent visiting the house, exploring the Renaissance-style gardens, admiring the architecture and enjoying some refreshments in their garden tea rooms.

Sherlock Holmes creator, Sir Arthur Conan Doyle, and James Joyce have both called Bray home. No 1 Martello Terrace, the nearest house to the sea in a charming terrace at the north end of Bray esplanade, was the Joyce family home, and provided the setting for the bitter row over the Church's part in politics in the Christmas dinner scene in *A Portrait of the Artist as a Young Man*.

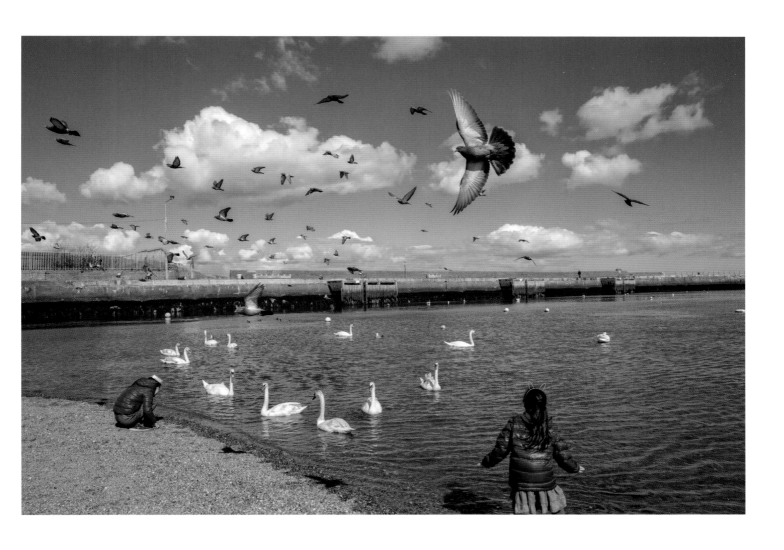

Feeding the thriving colony of beautiful mute swans at **Bray Harbour** is popular with families. The harbour was originally used by coal importers; there was a crane for unloading the coal, and the crane was also used to dredge the harbour. When the crane ceased operation the harbour silted up, preventing large craft from entering. Today, Bray is a tidal harbour with access for most boats. Bray Sailing Club runs courses throughout the sailing season, and club members race cruiser fleets and two-person sailing dinghys.

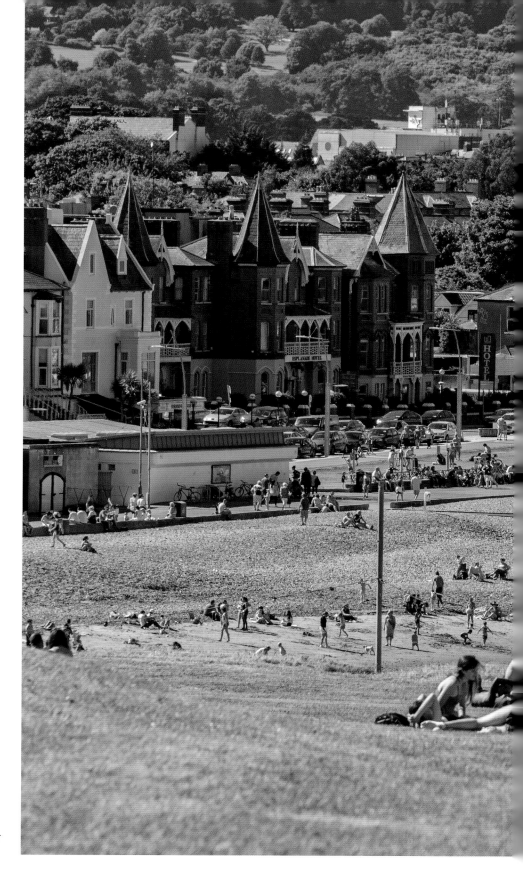

Looking back at the **Victorian seafront** of Bray from the start of the Bray to Greystones cliff walk. The promenade, with its hotels, restaurants, pubs and stoney beach, is popular with locals and visitors alike.

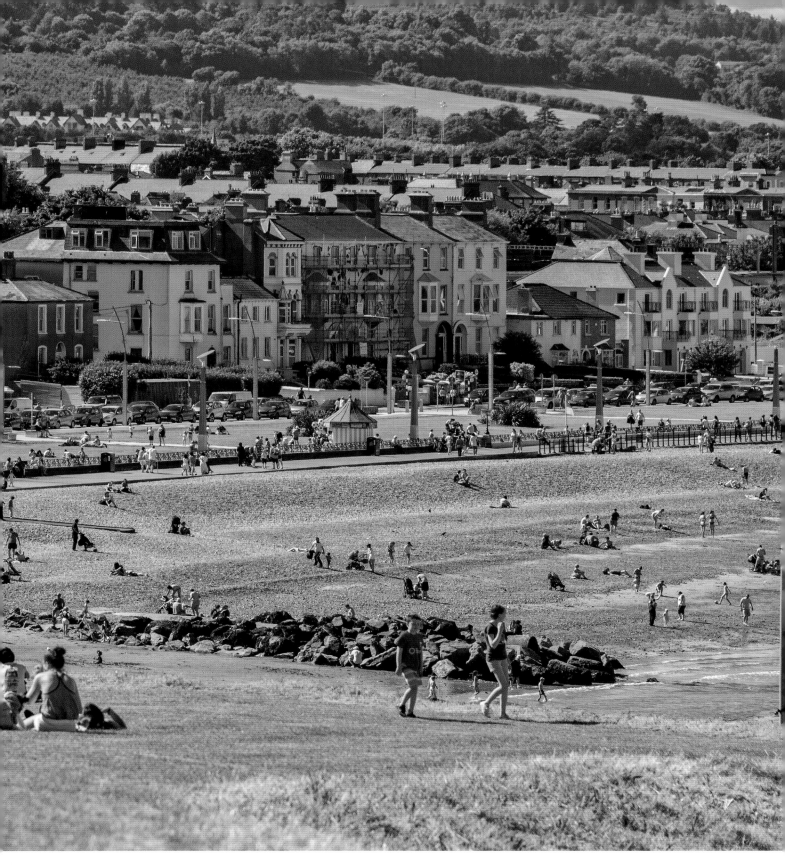

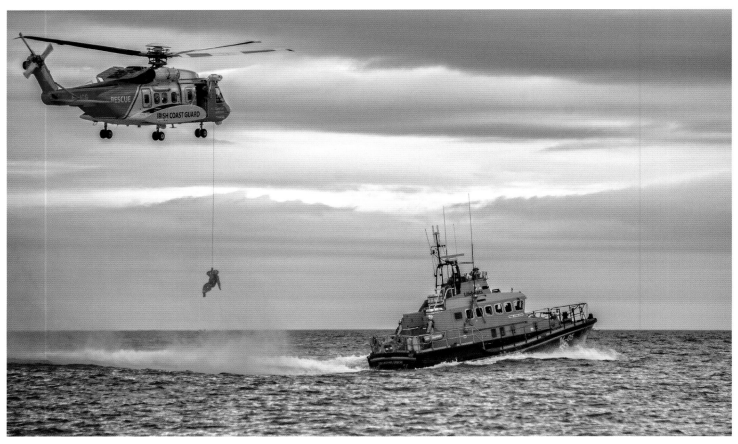

Top: Air–sea rescue demonstration during the **Bray Air Display Show**, carried out by RNLI and Irish Coastguard; both organisations keep everyone safe in the bay. There have been lifeboats on Dublin Bay for over 200 years, and they are moored at the key harbours of Dún Laoghaire and Howth, with teams of dedicated volunteers ready to race to rescue in an emergency – their aim, 'to save lives at sea'. Tragically the helicopter in this photograph, Flight 116, crashed while on a rescue mission in March 2017.

Bottom: Frecce Tricolori flypass to salute the crowds at Bray Air Display Show. The show is the main attraction of the annual **Bray Summerfest** which takes place every summer.

Right page: Walking tall. **Breitling Wingwalkers** preforming in front of 140,000 people at the Bray Air Display Show

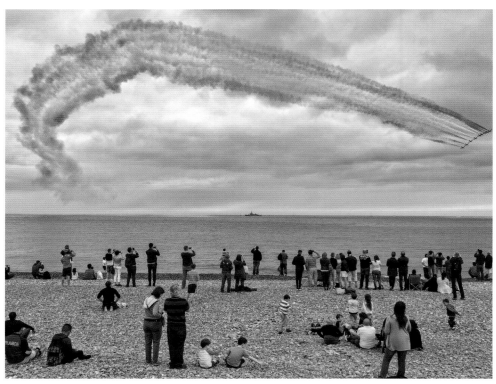

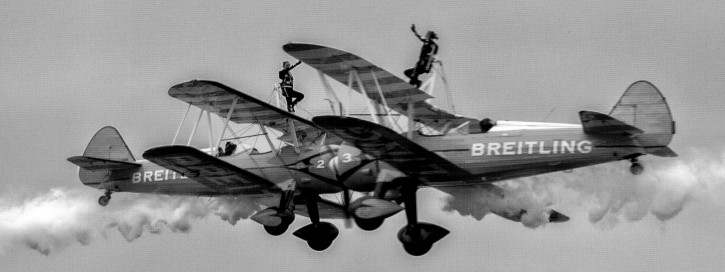

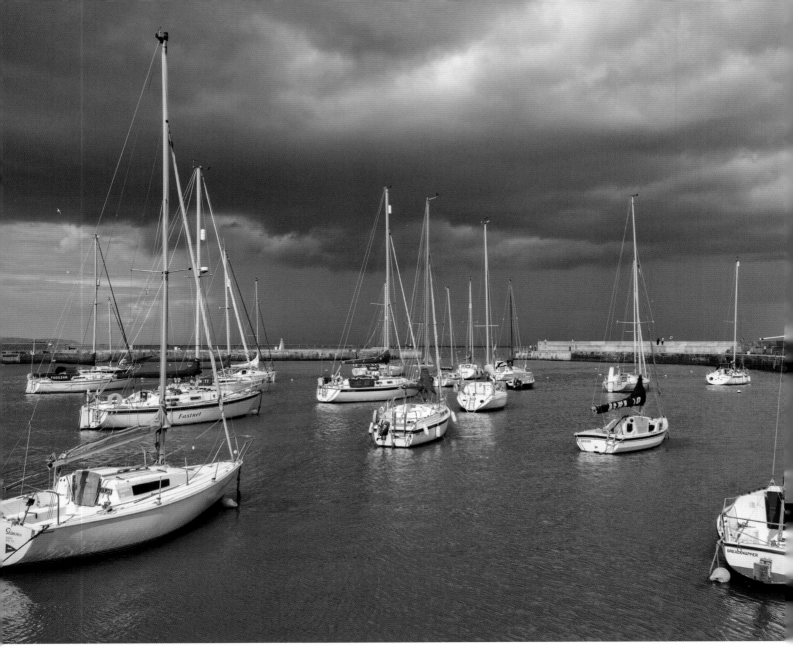

Above: Bray Harbour with rain out at sea.

Right page, top: For generations of people, summertime in Bray is synonymous with the amusements.

Right page, bottom: The Harbour Bar, voted The Best Bar in the World by Lonely Planet in 2010, offers an authentic pub experience and a passion for good music.

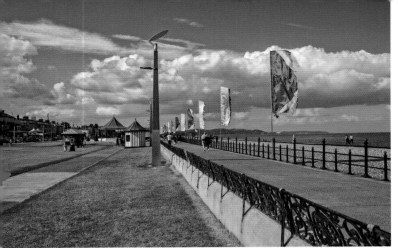

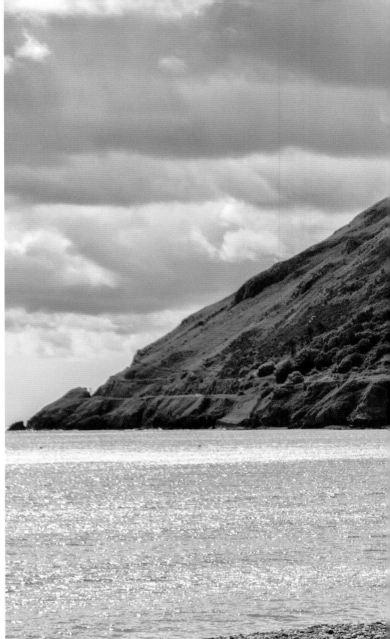

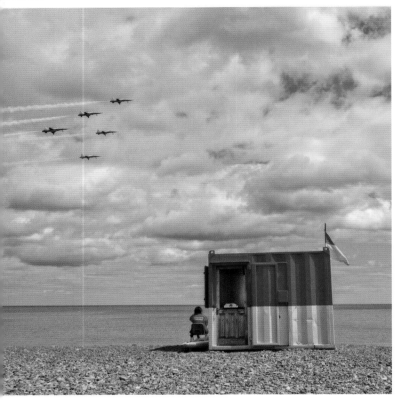

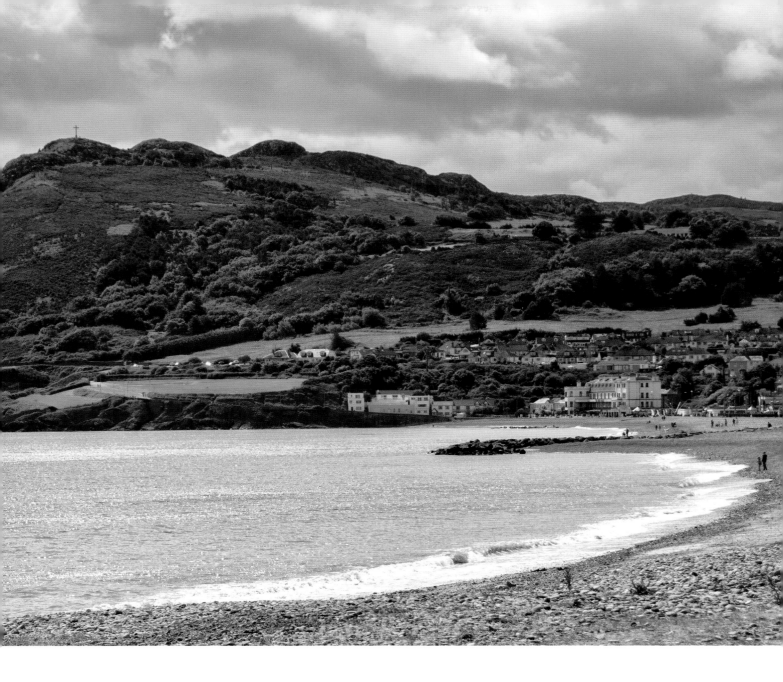

Above: Bray Head, 'the snout of a sleeping whale', as viewed from the beach. The challenging trek to the top rewards the walker with spectacular views out over Dublin Bay and inland to the Wicklow Mountains.

Left page, top: A quiet moment on **Bray promenade** – a classical Victorian promenade, retaining its period charm and a jewel in the Bray crown.

Left page, bottom: The Swiss Air Force aerobatic team, known as **Patrouille Suisse**, doing a practice run along Bray Beach in the days before the Airshow, hence the near-empty beach with just a lifeguard on duty.

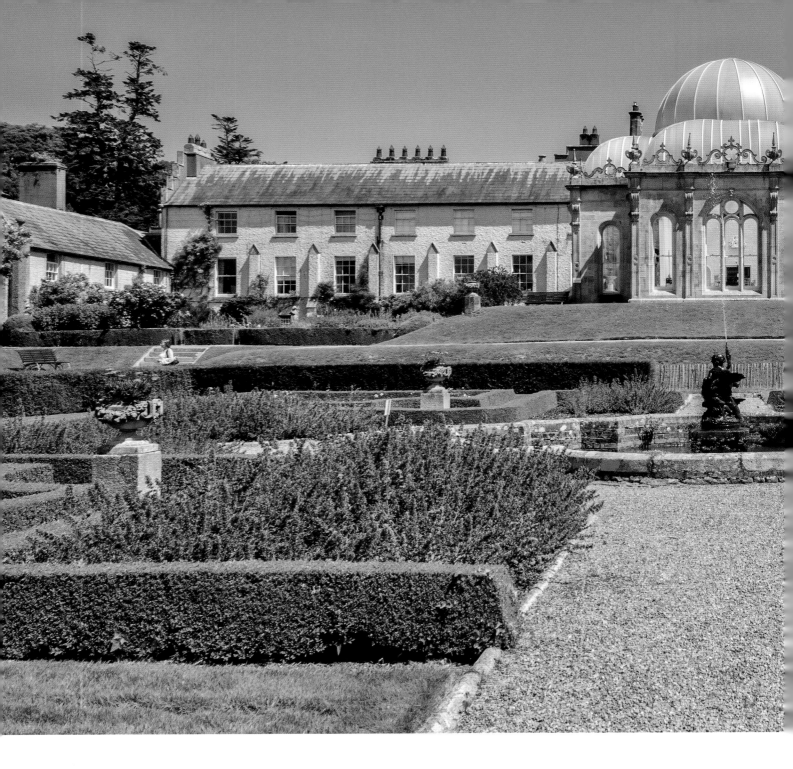

Killruddery House, a large country house on the southern outskirts of Bray, off the Southern Cross road, lies within walking distance of the seafront. With its beautiful 17th-century-style gardens, working farm, playgrounds and backdrop of the eye-catching orangery and the Little Sugar Loaf mountain, it is the ideal spot for a picnic or country ramble. The house hosts many seasonal events, and has a regular farm market at weekends.

GREYSTONES

The harbour town of Greystones is the final stop, going south on Dublin's suburban train line, the DART, which curves around Dublin Bay. On its approach into Greystones, the trainline hugs the cliff, with dramatic views for tourists and commuters alike. Whilst Greystones is in County Wicklow, it has, in recent years, become a satellite town of Dublin but still manages to maintain that village charm that is common to many places around Dublin Bay.

Greystones Harbour dates back to the late-19th century, and the original pier and sea wall remain to this day. It is a popular amenity with a weekend market where local craftspeople and food producers come to sell their wares. In recent years the marina has benefited from extensive redevelopment.

Greystones has two beaches, the pebbly North Beach and the sandy South Beach, which boasts Blue Flag designation. The area is popular with swimmers, and people can be found braving the cold Irish Sea all year round.

Greystones village has become a foodie haven, with a variety of cafes, restaurants and bars catering to all tastes. It is also home to a number of charming shops and boutiques.

Greystones Harbour is the starting point for one of the most rewarding walks in the greater bay area. Following the railway line, the 6-kilometre cliff pathway can be uneven at times, and the ascent at Bray Head can be challenging, if the upper walk is chosen. The Greystones to Bray Cliff Walk offers some of the best views of Dublin Bay. On a clear day you can see all the way to Howth with the Dublin/Wicklow Mountains as an equally dramatic backdrop. The pathway is so peaceful, and in places almost devoid of evidence of human intervention, that it can be easy to forget that you are less than an hour from Dublin city centre.

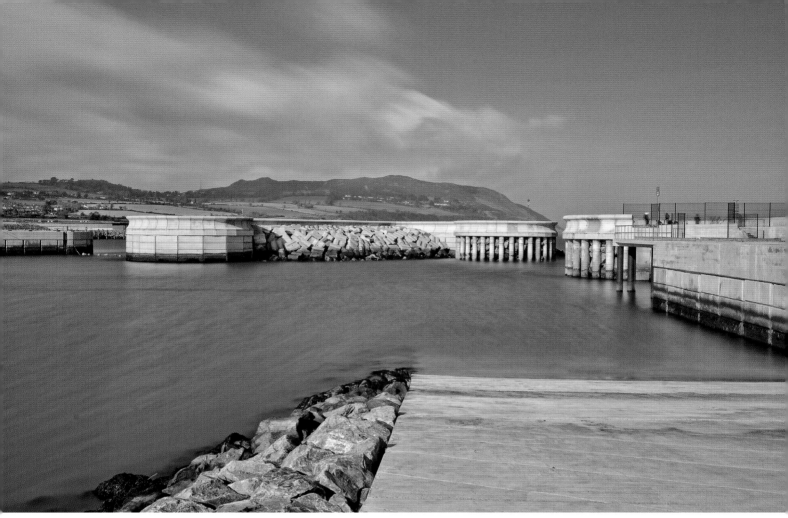

Top: Greystones' new **harbour,** with Bray Head in the background.

Bottom: The colourful and vibrant **Art and Photography Exhibition** held on summer Sundays at the harbour plaza.

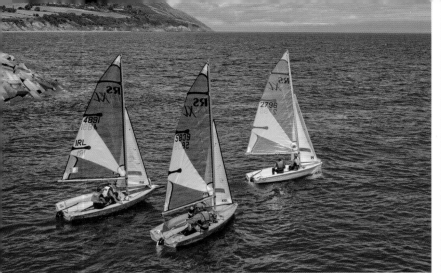

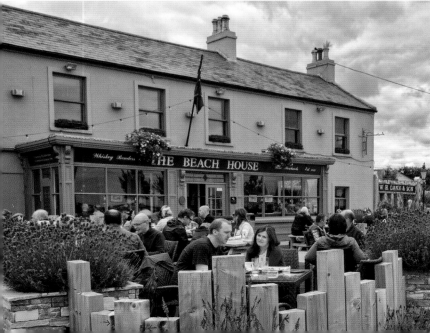

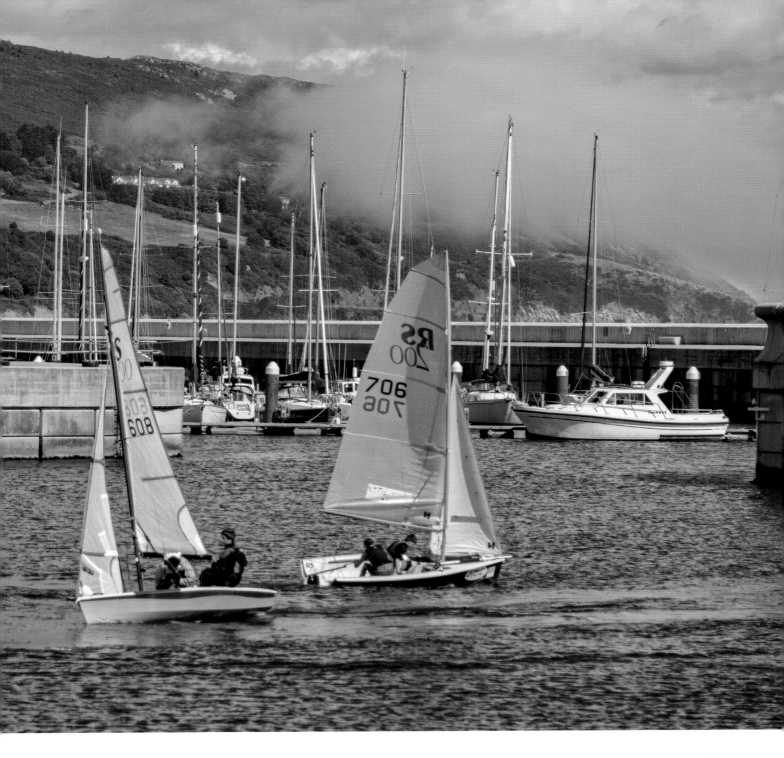

Left page, top: RS Fevas sailing yachts leaving Greystones for the National Championships, August 2016.

Left page, middle: Jewellery designer and silversmith, Jason Mac Gabhann of **Casúr Óir**, 'Golden Hammer', in the Boatyard Market.

Left page, bottom: Enjoying lunch at the **Beach House** bar and restaurant, opposite the harbour.

Above: Sailing in **Greystones Harbour**, with a rolling cloud on Bray Head.

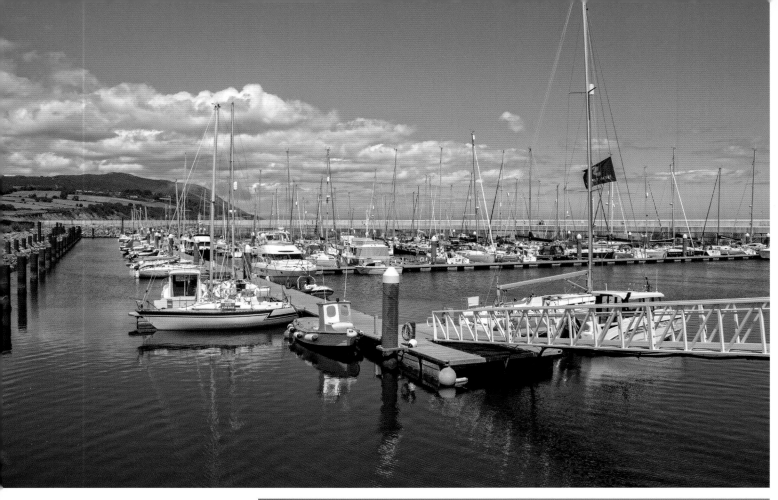

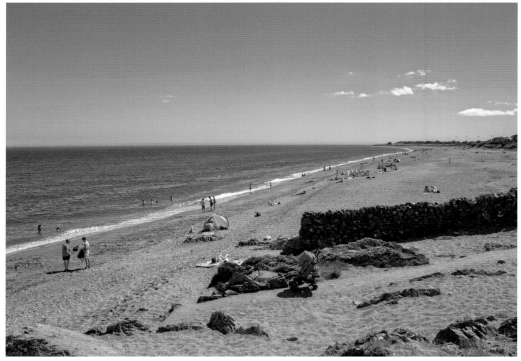

Top: One of the few marinas on the east coast, the new **marina** at Greystones is a major asset for visiting and local sailors. Gone are the days of lugging your boat across the stones to reach the water.

Bottom: The beautiful Blue Flag **South Beach** at Greystones is close by to the DART station. Walkers can make their way south to Kilcoole in County Wicklow all along the coast, with fine birdspotting opportunities on the way.

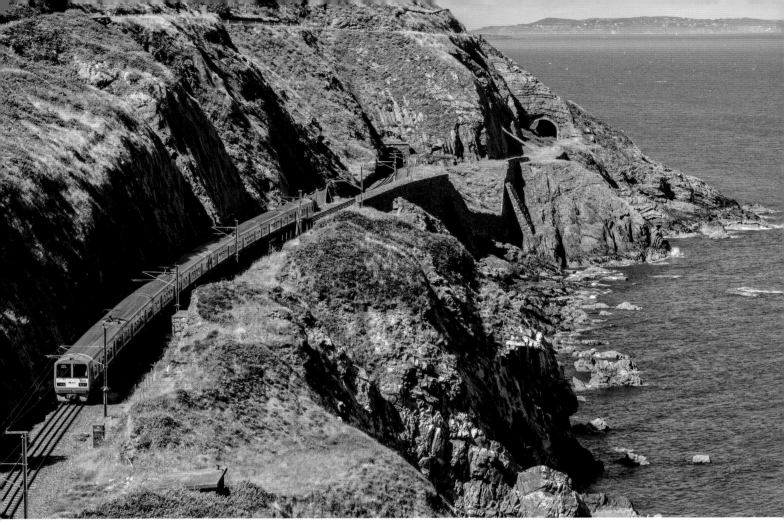

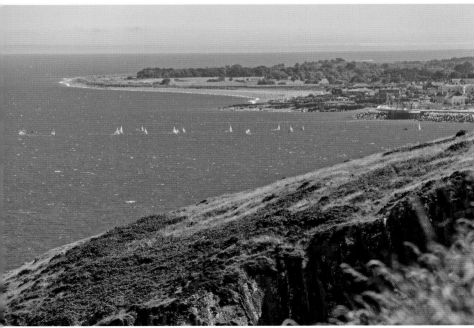

Top: Completed in 1856, the railway from Greystones to Bray runs on the edge of a cliff, and is flanked by a rewarding **cliff walk** that affords stunning views of the coast. Designed by Isambard Kingdom Brunel, the line became known as 'Brunel's Folly' due to the cost of maintenance and has required rerouting over the years, not least when a storm caused a section of the line to fall into the sea.

Bottom: View of **Greystones** from the cliff walk.

Top: Walkers making their way northwards along the **cliff walk**, with views towards Killiney and Howth.

Bottom: Nature's colour along the cliff walk. The cliffs are home to many species of flora such as heathers, red valerian and sea campion. The walk can be made all the more entertaining by spotting wildlife such as the common lizard, the small tortoiseshell butterfly and the many bird species that live among the gorse and rocks or cling to the cliff face.

Above: The ruins of **Lord Meath's Lodge** on the Bray to Greystones cliff walk; it was used as a toll gate when the walk was first opened.

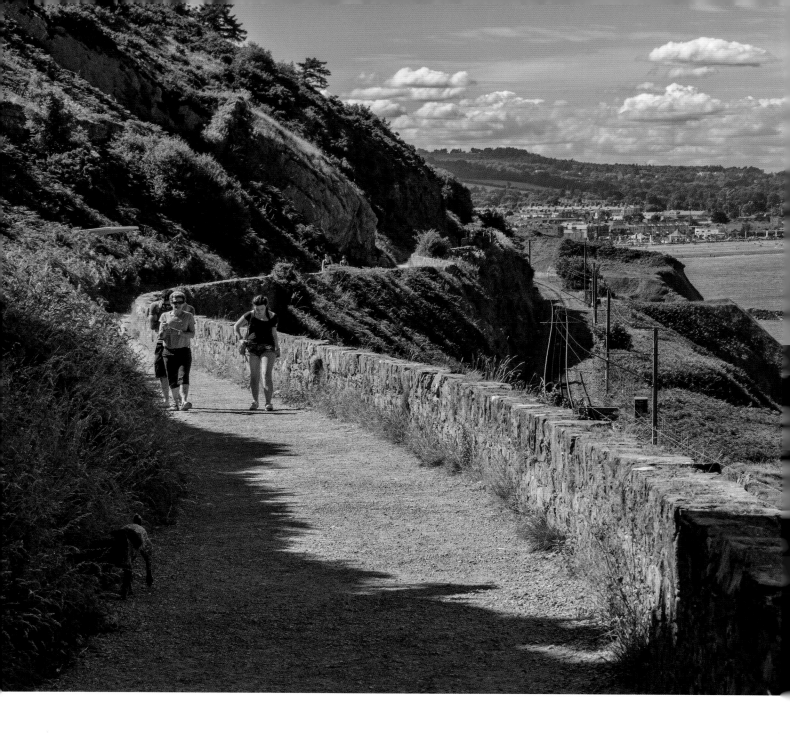

Above: Bray comes into sight as you round one of the final bends of the walk south on the cliff path.

Right page, top: Swimming and diving off rocks on a summer's day, on **Greystones** seafront.

Right page, bottom: The Happy Pear café, Church Road, one of the most popular places to eat in Greystones.

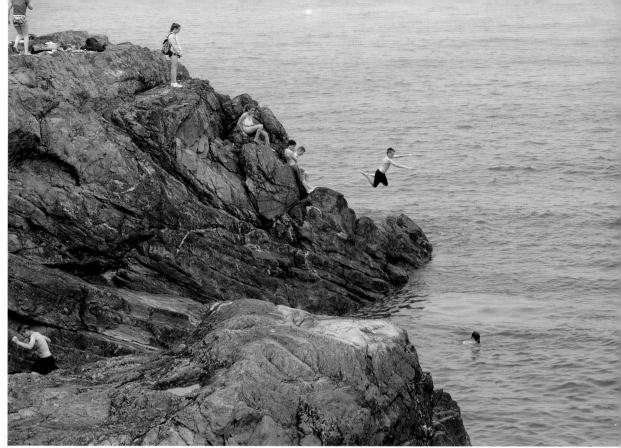

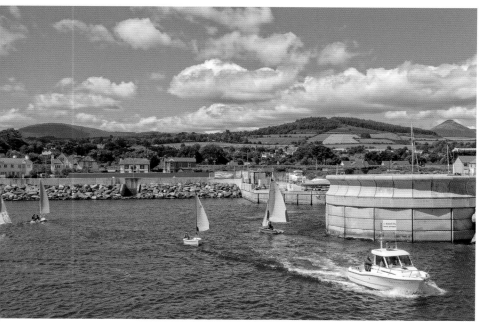

Top: *The Beach Bear*, a joyful figure by sculptor Patrick O'Reilly, on the promenade at Greystones was donated by family in memory of the late Caroline Dwyer-Hickey, a teacher at a local school who died of cancer at a young age.

Bottom: Coming into **Greystones Harbour**.